BEAUTIFUL/DECAY
BOOK:6
FUTURE
PERFECT

BEAUTIFUL/DECAY

PUBLISHED BY
Feral Children Productions, LLC

FOUNDER
Amir H. Fallah
ahf@beautifuldecay.com

CREATIVE DIRECTION
Something In The Universe
somethingintheuniverse.com

GRAPHIC DESIGN
Garret A. Verstegen
garret@beautifuldecay.com

COPY EDITOR
Jackie Lam

**CONTRIBUTORS/
PHOTOGRAPHERS**
Amir H. Fallah, Jessica Lopez,
Garret A. Verstegen, Bill Donovan,
Catlin Moore

PRESS INQUIRIES
contactbd@beautifuldecay.com

MAILING ADDRESS
Beautiful/Decay
World Headquarters
P.O. Box 2336
Culver City, CA 90231

In the Beginning...

I started Beautiful/Decay as a small black and white, DIY photocopied 'zine in 1996. Trapped in the suburbs of Northern Virginia, I was bored to tears by the uniform lifestyle that was the norm. Beautiful/Decay became my humble way of documenting all the things that my friends and I were taking part in, whether it was painting graffiti on trains, going to punk shows at the 9:30 Club, curating impromptu art shows in warehouses or getting kicked out by security guards at our favorite skate spots. We believed in making something out of nothing and breaking down anything that was in the way of our dreams. So, with a stack of photos, $100, and a few hours at the local copy-mat, Beautiful/Decay was born. We were young, full of creative energy, and had a desire to create something new and carve our own path in life.

Fast forward to today, and B/D still carries that same youthful sense of rebellion and experimentation that influenced so many of my creative peers and I. We still take risks, collaborate with new and unknown artists, and veer away from the mainstream to make products of substance. In the 14 years since our inception, the brand has gone from a part-time hobby to an internationally recognized design-driven lifestyle brand that publishes books, designs apparel, and provides creative platforms. More than just a brand, Beautiful/Decay is a lifestyle for those who see beauty in decay and push creativity to its limits to make something new and inspiring for our generation.

Long live the cult of decay.
-Amir H. Fallah

STAY INFORMED
STAY ORIGINAL
STAY CREATIVE
STAY INNOVATIVE
STAY INSPIRED

TABLE OF CONTENTS

INTRODUCTION:

11

A perfect future means different things to all of us. Whether your version is an idyllic utopia, a commune in the forests of Oregon, or just a world with less pollution, everyone has the ability to contribute to a better tomorrow. You can contribute large or small by doing anything, from reducing your carbon footprint, to lobbying for environmental causes, running the faucet less, or by following a vegan diet. The little things we do today make a difference tomorrow, and this book aims to remind us that everyone can take part in a Future Perfect.

For Book 6 we teamed up with Toyota Prius to give back to the creative community in hopes of fostering the careers of a new generation of creatives. With our Future Perfect competition we asked you to show us what your ideal future would look like. We received over 300 submissions spanning every medium, technique, and style. It was inspiring to see how talented the Beautiful/Decay community is. Narrowing down all the top-notch submissions was a challenge, but after many hours of deliberation you are about to experience the works of the grand prize winner and over 100 finalists.

We are also excited to have a feature-length article about extraordinary painter Robin Williams, whose surreal paintings give us a view into her own Future Perfect. To top it off, we have an interview with our Future Perfect grand prize winner Corey Thompson. Thanks to everyone for contributing to Book 6 and for joining Beautiful/Decay in creating a Future Perfect.

—Amir H. Fallah

6a.

6b.

7a.

14)

ROBIN
WILLIAMS

ARTICLE BY: Catlin Moore

Images courtesy of the artist and P.P.O.W Gallery, New York.

In 1988, critic Dave Hickey predicted the future.

Beauty, he claimed, would be the primary issue of the art world in the 90's. True to his reputation of a smart-alecky dissenter, Hickey had partially intended the speculation as wry provocation rather than gospel, but his conjecture ultimately came home to roost. In fact, it still seems quite comfortably camped out. Every so often, the notion of "beauty" soars overhead and casts an ominous shadow over contemporary art's turf—feared by most as the predator of rigor and stimulus. Says Hickey, "I had assumed that from the beginning of the 16th century until just last week artists had been persistently and effectively employing the rough vernacular of pleasure and beauty to interrogate our totalizing concepts 'the good' and 'the beautiful.' And now this was over? Evidently."

Not for some. The critical brawl between drop-dead gorgeous and shrewdly conceptual finds equal footing and armistice in the spellbinding paintings of Robin Williams. Not to be confused with the woolly *Patch Adams* personality of the same name, Williams reconciles the resplendent opulence of 17th century portraiture with folklorish whimsy and surrealism in her slightly distorted tableaux. She peddles the kind of "uncontrollable beauty" that Hickey feared extinct, but with a sharply absurdist bite. In the current knock-down-drag-out resistance to all things too "easy on the eyes," the Ohio native proves that beauty doesn't have to be pretty—its magnetism can be found in the awkward, lanky, slack-jawed splendor that her figures often personify. Flirting with the nightmarish and perverse, romantic and nostalgic, Williams' subjects appear paused in languid thought or entrancement—their glazed stares fixated on a nebulous future, subtly disquieting in their docile resignation to the unknown. "Everyone reacts differently," she notes. "My parents tend to find them disturbing and are always asking me if I'm OK."

Williams' hands gesture with authority as she seemingly conducts an improved symphony, her tousled blond hair nodding along with her head as she emphasizes her point. "Other people find them funny, and some people even find them sweetly innocent and charming. But I think that may be the way most people are used to perceiving children, and it's an automatic response. Lots of people find them a bit creepy. It doesn't matter how people take them as long as the work is interesting and hopefully challenging."

Challenging? Could it be? Stimulation dexterously cloaked in a radiant palette and masterly technique? Hark! In the exemplary "Party Hat" (2008), a young girl is posed in an inelegant rendition of a musing duchess, her head coiffed with richly hued feathers akin to European aristocracy. Her gaze is effeminately turned over her shoulder, as her petite fingers dig into her sallow cheek and her drooping lips share a greenish tint with her glassy eyes. Like Linda Blair in regal headwear, something is clearly amiss, albeit alluring. As if caving under the weight of a sensationalized history and tradition, Williams' sickly figure seems disconnected and overwhelmed by the bounty upon her head. "I like 17th century portraiture because it evokes the feeling of a longstanding empire. Combined with awkward teenagers and slightly absurd costuming, I'm calling into question the permanence of America's position at the top of the heap," says Williams. "It's also about a young generation coming to terms with that reality and having to question who they really are in the world, myself included."

Empires, like youth, are transitory. With the horizon both dauntingly looming and enticingly inviting, the future seen through the eyes of a child is filled with the same dizzying promise and expectation as it is for the newly elected. The

"Cyclops," 2011
Oil on canvas
44" x 60" →

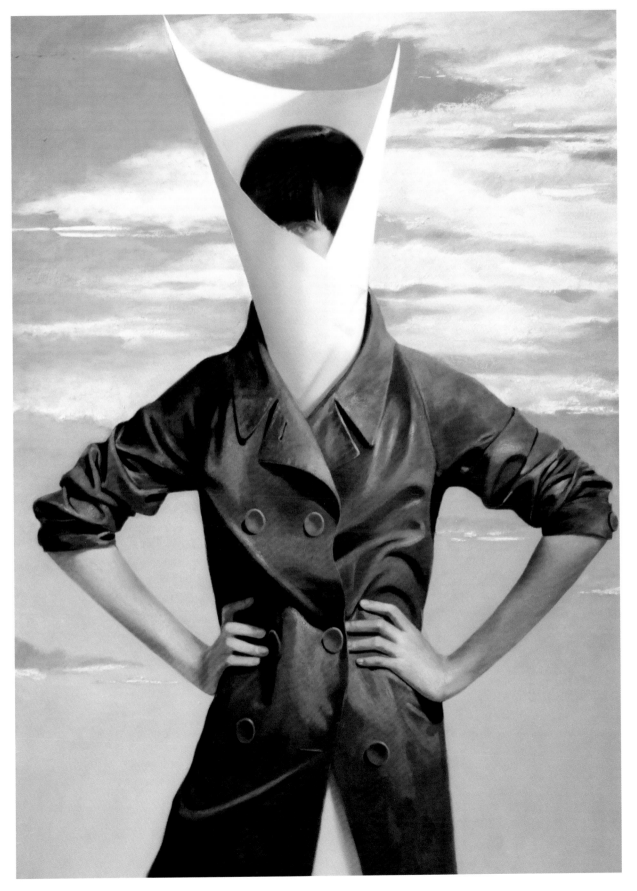

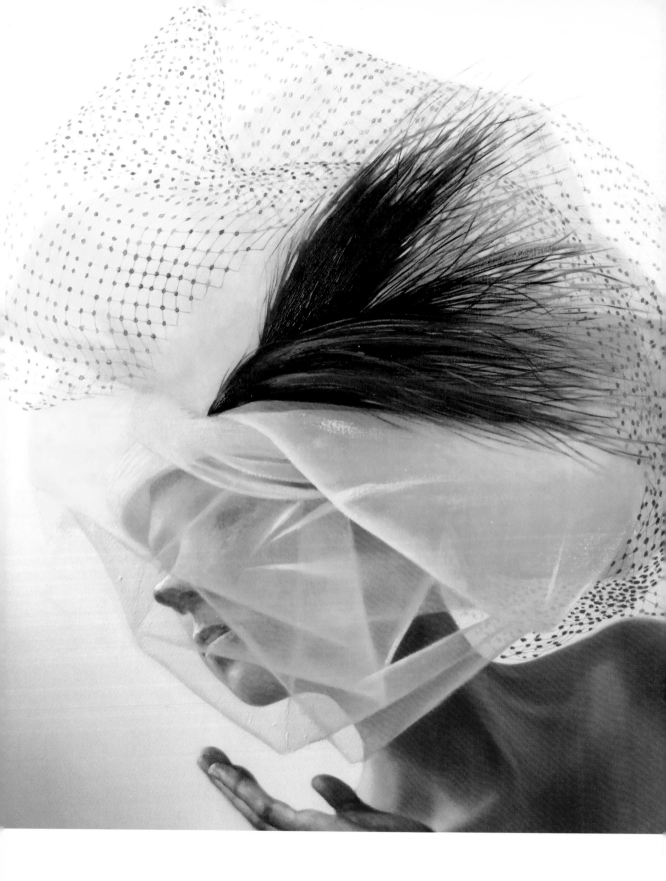

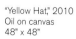 "Yellow Hat," 2010
Oil on canvas
48" x 48"

"Boy with Sticks," 2011
Oil on canvas
64" x 78" →

intoxicating elixir born of hope, anticipation, and anxiety is an unwieldy beast, and much like the throes of adolescence, induces us to constantly mine activities for meaning and resonance. Williams' painted youth embrace the meandering discovery often trivialized in self-development–despite its psychological and emotional gravity. In "Pocahontas" (2009), an androgynous "tween" floats upon a placid jade green lake in an inner tube, nude save for a costume Native American headdress and without distinct expression – as if the subject is only slightly conscious of a greater world beyond the immediate. In "Swoon at the Water Pump (2010)," a blue-bonneted girl lies sprawled by a water pump, her pink petticoats twisting in biomorphic layers beneath her dress as she nonchalantly stares into the dusky clouds above. The utopian state of being and innocuous engagement with one's environment is spared exhaustive critique or accusation in Williams' depictions, a wistful nod to the tranquil moments of imagination innate to our formative years both as individuals and as a society. She clarifies, "The kids became vehicles to discuss young adulthood, or the American Dream,

or inherited privilege. I think this last body of work had a lot to do with how external states of being influence our internal sense of self. There is a kind of shape-shifting that happens in adolescence that speaks to that, which made them good subjects for the concept." Williams' dioramas naturally bear an uncanny kinship with the illustrations of vaguely familiar fairy tales, given the omnipresent myth of Happily Ever After in privilege's greatest suppositions. Folklore, complete with resolution and promise, made modern society believe in a ubiquitous narrative arch. Surely, there is an order of operations in the achievement of happiness and actualized selfhood; one simply has to stumble upon them in a magical twist of fate or through dedicated wistful yearning. If menacing creatures (ex-boyfriends) or bewitching curses (useless college degrees) should occur, consider yourself on the right path. The longing of Williams' subjects for such a digestible plot is palpable as they seemingly pine for the right cues and resemble a hazy incarnation of pop culture's fanciful protagonists. "Maybe that's Trina Schart Hyman's influence on me. I had at least twenty of her books when I was kid,"

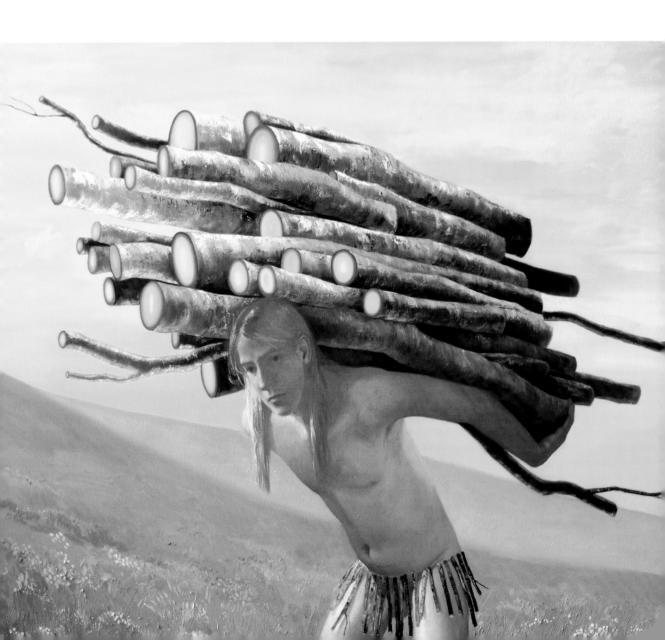

she professes. "She illustrated so many fairy tales that are likely burnt into my brain. But I think stories are powerful and they shape our identities. There is comfort in stories; there is certainly an order to them. I'm injecting a certain amount of unease into those stories—or, at least I hope to. These stories have the potential to be problematic, and limiting, not just comforting. I think it's tempting to live them out long after they've become irrelevant because it's frightening to live without them."

In Williams' personal story, the origins of her artistry are tied to the liberties of childhood with a dash of accelerated maturation. The Rhode Island School of Design graduate recalls, "My grandmother started taking me to weekly art lessons when I was 5 years old. It was an intergenerational informal class held mostly in my teacher's home. So for three hours every Wednesday night, I painted or drew whatever I wanted with a bunch of middle-aged women

and a few teenagers." With the intersection of ages and influences acting as an early factor in Williams' exposure to art, the mock-adult postured mannerisms of her young subjects seem quasi-autobiographical. Often posed in the courtly manner of the upper echelon of bygone eras–ala Velásquez or Vermeer–her models are typically engulfed by garish costume, as if consumed by the obviously ill-fitting attire of an equally inappropriate identity or forced selfhood. These are children ushered into adulthood prematurely, into a predetermined typecasting by way of societal diagnosis– cultural habits that are poorly tailored to one's actual personality and are as awkwardly cumbersome as Williams' rendered spherical neck braces or foil capes. "The objects often overwhelm the figures and compete for prominence in the painting, which is intentional" she explains. "When you're dressed like a prince (as in the piece, 'Tired Prince' [2010]) maybe you'd like to believe you're a prince, rather than looking closely and realizing you're a fool. Maybe it's about

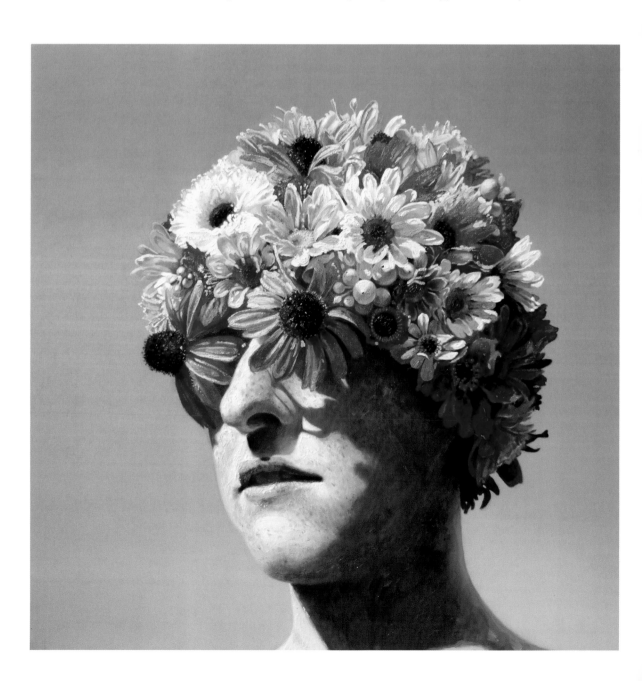

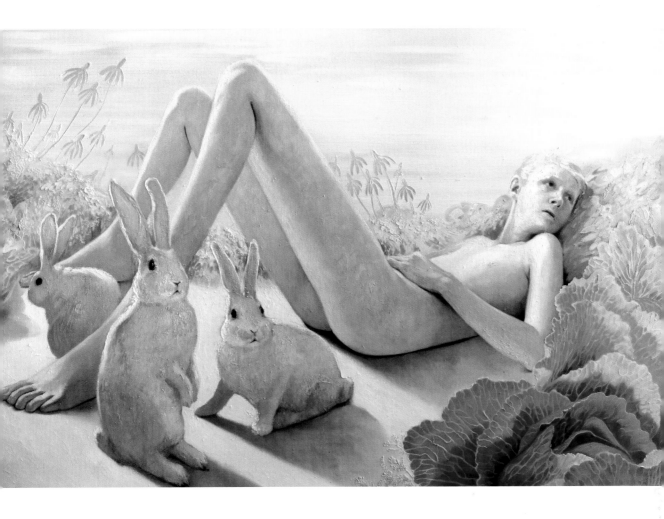

"Flower Cap," 2010
Oil on linen
48" X 48"

"Cabbage Patch," 2010
Oil on linen
44" x 72"

artifice or giving artificial things more significance than they are owed, but at the same time, I deeply enjoy painting them. I also like to make tacky, disposable things into something falsely grand. Mylar, ruffled petticoats or birch bark are fun things to paint."

Fun. Nipping at the heels of "beauty," "fun" often finds itself struggling for credibility in the great artspeak vernacular. As Williams seems to relish testing the frontiers of our own egos, she employs a deft sense of humor to confront the very essence of life's greatest tragicomedy: pubescence. In navigating the uncharted waters of young adulthood, drama and disillusionment unfold as heroes rise and fall, love waxes and wanes, and hormones unleash a cannonade more savage than any Shakespearean tempest. This, of course, all before curfew. However harrowing the journey seems from behind the helm, in retrospect the comedy reveals

itself—commonly in the forms of unfortunate prom dates and/or choice in hairstyle—as resolved identity proves the fruit of maturation's labor. Williams' figures are clearly steeped in the frustrations and befuddlement of their own condition: furrowed brows, lethargic stares, and mouths agape implore the viewer's empathy while also prodding at the amusing nature of youth. Traces of recognizable self-consciousness and vacillation are legible in Williams' oils, namely in the form of angular limbs, freckled pouts, and protruding overbites. Yet in those maladroit aesthetics, there's a kind of honest elegance that is full of possibility and expectancy, reflective of an age where the future can only hold promise. "I have to admit, I have been attracted to a certain kind of freckled, wholesome white American teenager with a degree of awkward gawkiness in my paintings," she concedes. "Maybe it's because I grew up in a pretty homogenous place—Columbus, Ohio—where that was the norm. I like them to

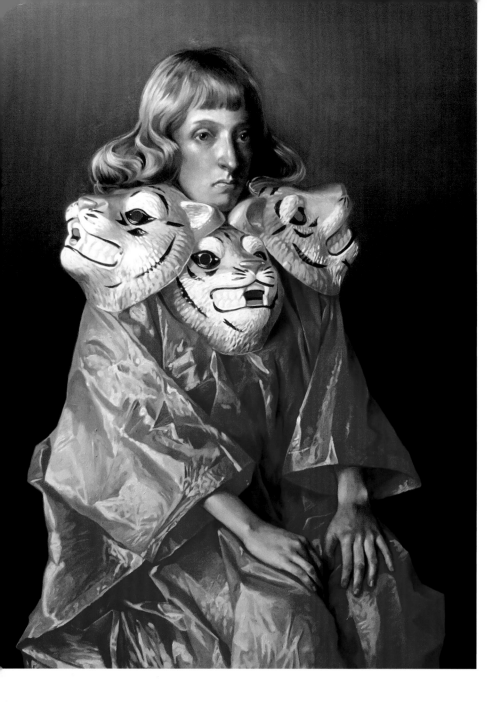

"Neckpiece," 2008
Oil on canvas
54" x 40"

look a bit inbred. In making art about children, I think I'm always implying that these figures are inheriting the world. There's something stunted about them and their subsequent behavior—some of them know it and it scares them. Ultimately, they'll be a part of an increasingly complex, globalized world where their baggage as Americans will finally catch up with them." But for now, in the harlequin tinted and picket fenced realities of her paintings, Williams' youngsters are blithely unaware of anything other than their own imaginations and pipe dreams. In 2010's "Rescue Party," a green, inflatable kiddie pool sits atop a well-manicured lawn, and bulges under the weight of its six stationary occupants. While one boy is splayed over the side of the aerated vessel, melodramatically submissive to the events ahead, another puffs his chest— hands firmly planted on defiant hips—at the presumed front of the imaginary ship hull. Nevermind the funny hat or unconvincing stature—he is the captain, damn it. Distraught

passengers aside, they can stay afloat based on sheer ambition and guileless optimism, much like the composition's art historical predecessor suggests.

Notes Williams, "I don't often make direct references to specific paintings with the exception of 'Rescue Party,' which was a (somewhat cheeky) take on Géricault's 'The Raft of the Medusa.' I sort of couldn't help myself." She slyly grins, her chin delicately cupped between her thumb and forefinger. "I mostly try to avoid those kinds of direct references, but I'm certainly hoping to evoke the formality of them. I like that for so long there were rules about how to make a proper portrait and now there are absolutely *no* rules. So there is really something conceptual in going back to the old rules anyway."

For every figure suffocating beneath the eccentric garb of Williams' ostentatious outfitting or flailing under the weight of

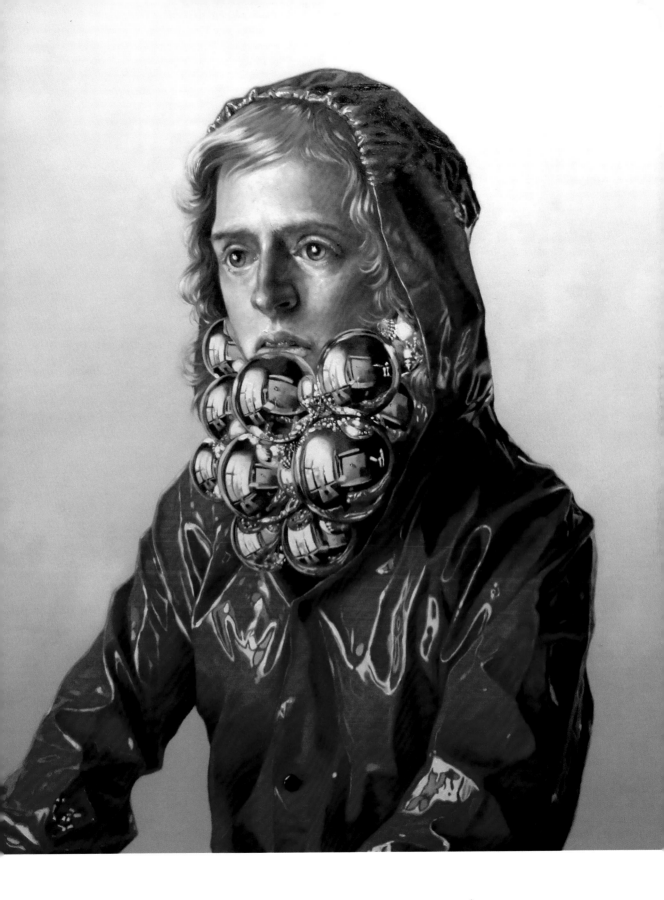

"Ornamented Boy," 2008
Oil on canvas
52" x 52"

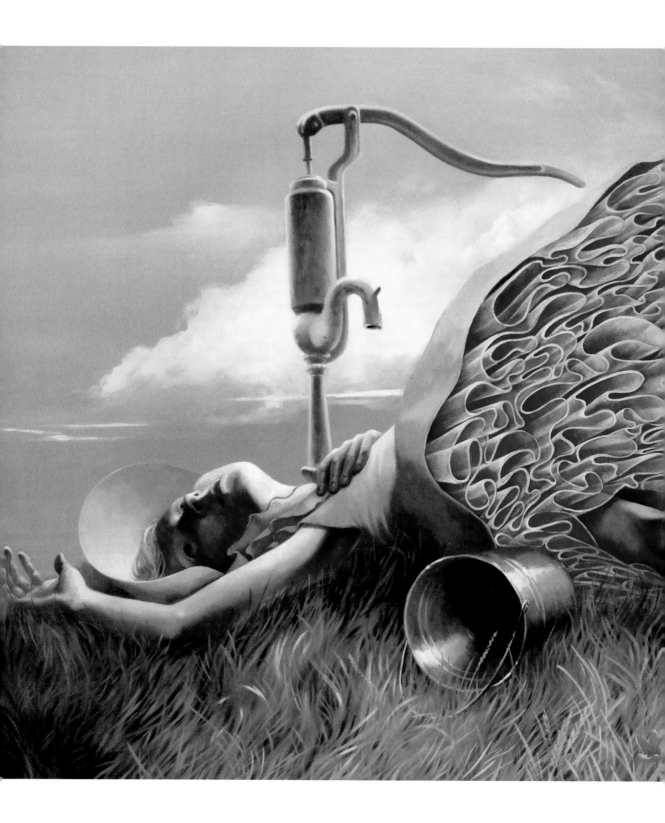

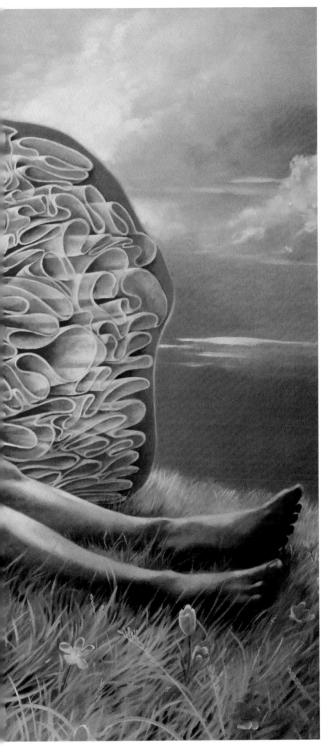

"Swoon at the Water Pump," 2010
Oil on canvas
42" x 64"

uncertainty, there is another floating in unbridled lightness. In 2009's "Back Flip," a towheaded boy is in a hypnotic mid-air somersault, as if being levitated from his plastic patio chair into the sherbet-colored sky. Both an allusion to a heightened sense of enlightenment by way of innocence, and the stagnant suspension of memory, his buoyant body evokes the dreamlike repose of sentimentality and fantasy. "I'm interested in the inner life of the subjects," says Williams, fingers splayed in accentuation. "I think I'm going after a certain sense of awakening, or if not, a kind of aimless floating. There's a lot of uncertainty and liminal states of being. Some of them are simply 'going through the motions' or engaging in habitual behavior brought on by nostalgic haze. I like them to almost be on autopilot, or else coming in and out of that condition. It's a pervasive modus operandi for the subjects in the work because it feels true to me, like something we do all the time." A similar lightness is exemplified in Williams' painterly hand; her works are like a subtle *trompe l'oeil* that coagulates into precise figuration from afar, but dissipates into abstract gesticulations upon closer inspection. Frenetic dots, dabs, strokes, and spots seem calculated in application, yet fluid in composition—intimating Williams' affection for the playful and instinctual. Not overly dissimilar from her subjects, Williams gracefully floats between myriad techniques and styles, embracing the virtues of the mercurial and the strange that pushes back against mechanical routine. "So much work now seems very calculated," she muses. "I'd rather my work be 'beautiful' in an unaffected way than be 'ugly' and more 'relevant' in a premeditated way. Beauty is such a tricky subject—it seems stuff has to be 'ugly' and 'raw' to be honest. Maybe because the media uses beauty to sell us things and it seems like an insincere way to make images, but that being said, I don't make the work I make without considering the form it's taking conceptually. I think the way I paint serves the idea behind the work. I absolutely do not think that beauty is inherently sentimental—it's interesting and challenging for me to make something beautiful that examines and questions the idea of sentimentality, nostalgia, and 'simpler' notions of the past in both art and life."

Following her recent solo show, *Rescue Party*, at P.P.O.W. Gallery in New York earlier this year, Williams has turned her attention to an altogether different source of mystique. "I want to paint women," she muses. "I've been painting children for so long, I'm ready for some adults. I'm interested in what it means to be a female artist, and finding ways to paint women

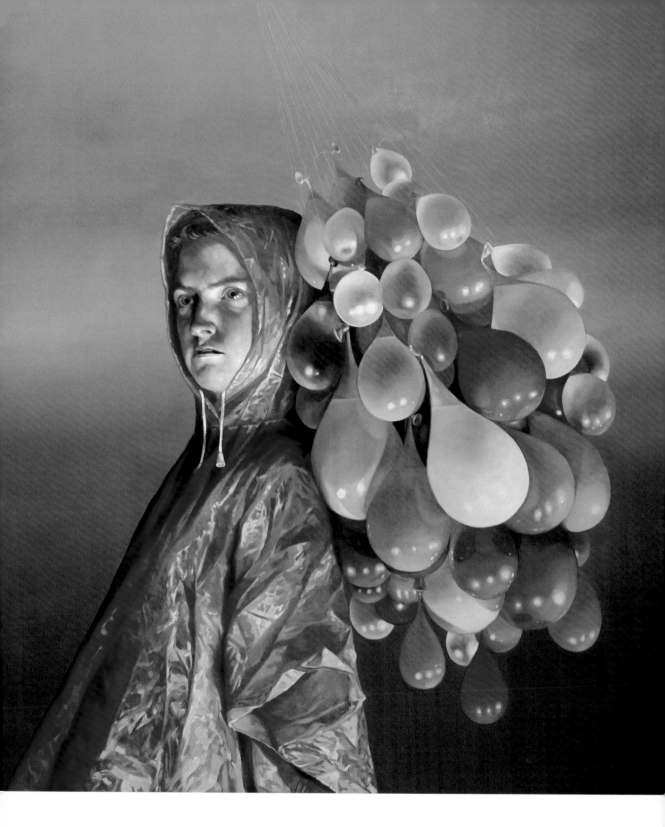

"Place Holder," 2008
Oil on canvas
48" x 54"

"Back Flip," 2009
Oil on canvas
60" x 52"

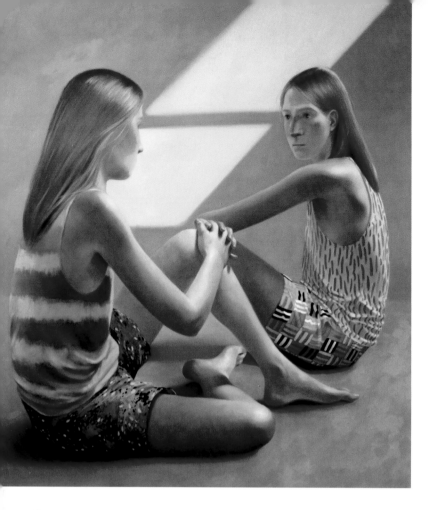

"Staring Contest," 2011
Oil on linen
60" x 54"

that expands on the way they've been painted for centuries. It's tricky, and well-trod, so I'm going to try to carve something out." Perched precariously on an easel in her studio, one such painting already exists. A confluence of Williams' emblematic art historical references and stark anatomy, the work immediately bespeaks a romance between John Currin, Georges Seurat, and–well–Tilda Swinton. While riddled with curious oddity, the painting is sumptuously textured and saturated. Not one to be a shrinking violet in the face of artistic daring, the 26-year-old will likely tap into her trove of vinyl ponchos, Christmas ornaments, plastic animal masks, artificial flowers, cellophane, and hats during her upcoming residency at the MacDowell Colony in New Hampshire. "They bring you your lunch in a picnic basket–*come on!*" she exclaims. "But in all seriousness, some of my favorite painters and authors have come through that place and I'm honored and excited to get to experience it. No deadlines and plenty of room to explore." With an eye on the horizon and solid footing in fleeting moments passed, Williams unwittingly asserts conviction in beauty's finest form: uncertainty. Mr. Hickey, it isn't over after all.

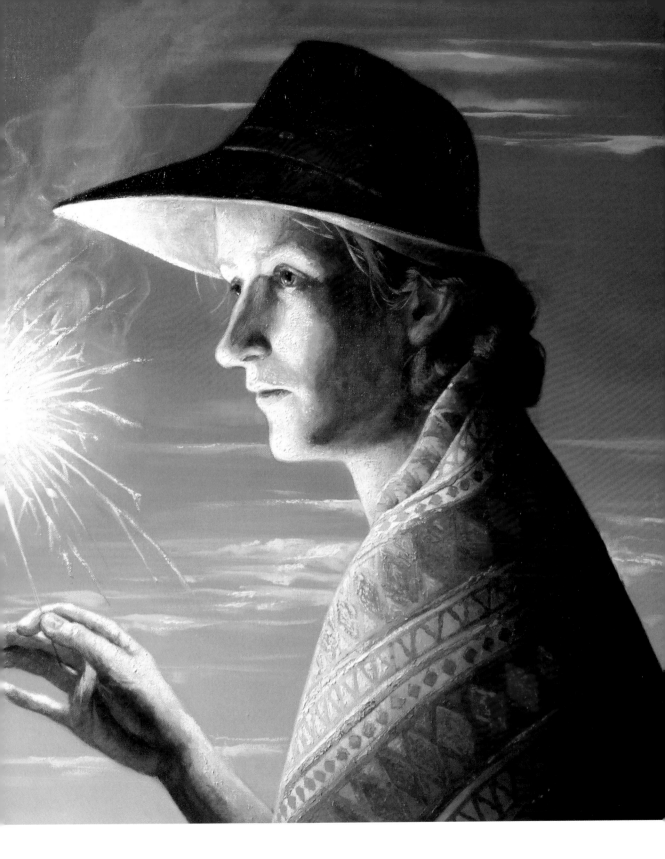

"Woman with Sparkler,"
2009
Oil on linen
48" x 40"

123
312
231

213
132
321

Фиг. 5.

S
A
E
O
D
B
C

3.

7)

9)

a

8 b.

8)

COREY THOMPSON

ARTICLE BY: Bill Donovan

Images courtesy of the artist

Corey Thompson's award winning work blends a sophisticated eye with a light hearted take on everyday subject matter.

Corey Thompson, the winner of the Beautiful/Decay Future Perfect contest, deserves it. It was difficult to choose one person's work from the huge amount of *excellent* entries we received. After days of discussion, we finally had our pick. We chose Thompson because his work blends a sophisticated eye with a lighthearted take on everyday subject matter. His use of melodious color combos, clean lines, and off-kilter compositions combine into a mellow amalgamation of finely worked chillness.

Yeah, sure Thompson draws purple weirdos with melting, pimply faces, atomic bombs detonating into mushroom clouds, and has a fondness for dismembered, tattooed arms, but there's a *je ne sais qua* under the surface that says "trust me, things are going to be OK." Yes, that arm happens to be ripped off at the elbow and there's a little heart-shaped nub of bone sticking out, but look carefully, because it's also giving you the thumbs-up.

That's the kind of optimism we need going forward in the future, and in our interview Thompson was asked to put on his Nostradamus hat and describe his Future Perfect. Thankfully, he doesn't get apocalyptic. Instead, he offers future civilization some sweet ideas for urban planning based on Ewok cities, and explores color schemes for space colonies in distant galaxies.

If we take a page from Thompson's sketchbook and relax, things will get amazing. Physicists think there may be eleven dimensions, and that humans only experience three. Biologists tinkering in labs are creating new varieties of life from scratch, like baking cookies. Tech-savvy inventors are starting to build nanomotors smaller than dust particles. If either bioengineering or the projected technological singularity delivers their potential utopias, scientists will be able to rewrite the code of reality, and we would experience a paradigm shift in what it means to be human.

That's why a recent drawing that's part of Thompson's Super Daily Doodle project, where the words inside a word bubble "Don't Have a Cow Man" spill outward concentrically, starts to talk about bigger ideas than just being worried. It addresses the future. Wiggly after-images radiate from the letters like ripples glossing over still water. The words are digitally painted in dusky lavender and rose. I want to call the background black, but the color is closer to the dark gray of worn-out black denim. And the image is comforting.

But not everything has to be edgy. Thompson uses the peace sign as a sort of logo, the one made by raising your index and middle fingers in a V-shape and crossing your thumb over the ring and pinky fingers. He also makes drawings and mini-animations about dreaming and chilling in the woods, and even gets an occasional Portland Trail Blazers logo into the mix.

Thompson uses some techniques and images we all know and love. The old-school computer spray paint tool makes for a nice pixelated edge in choice spots. And I think we've all drawn smiley faces and love notes with that crafty little spurting, pixelated spray can. Some of Thompson's images have a generous yet expressive cartoon form, which brings me back to classic psychedelic kids' shows like *Schoolhouse Rock!* or *H.R. Pufnstuf*.

Thompson keeps some rad sketchbooks too, and some of its pages are online. You can get a taste for his inventiveness with form after clicking on a few. He uses the paper (and monitor screen) in multiple ways: Sometimes the paper is a surface for images to float over or get jumbled up on, and sometimes it's a cover—the real action is taking place beneath the paper. In one choice drawing, what first appears as black apostrophes situated at the bottom of vertical, ragged lightning bolts, reveals itself to be tiger claws ripping through the surface of the paper. *Rawwwrrrr.*

Corey, your work feels as though it's coming from a good place. If I were to pick out one quality, I would say it's got a happy vibe. Does making art put you in a good mood?

Yes, definitely. I wouldn't be doing it, if it didn't.

That's a refreshing viewpoint. Can you talk a little bit about what engages you? What are some sources of inspiration?

I try to grab a little inspiration from everywhere: comic books, magazines, movies, music-pretty much anything I come across.

It's fun to mix inspiration from a bunch of places in a pot and see what comes up.

Were you born in Oregon?

Nah, I moved out here after high school to go to college.

How did you first get interested in making art? Were your parents into it?

My grandma used to do landscape paintings. I believe that was my first introduction to art, and I'd probably say comic books and cartoons/anime got me interested in making

IDEAS COME FROM HERE.

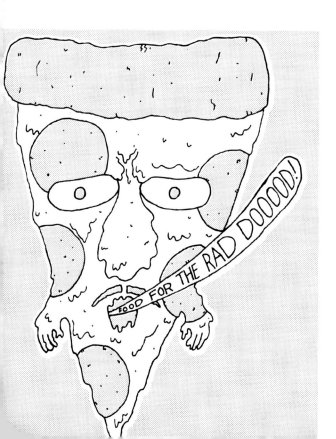

PIZZA DUDER

it. I remember growing up and buying comic books just to look at the art. I don't think I ever read them.

So you were into comics. Were you into skateboarding or punk? If not, what was your gateway subculture?

Yeah, when I was younger I wanted to draw comics for a living. I remember pouring over *How to Draw Comic Books the Marvel Way* a lot as a kid. I also loved art on skateboard decks, but never skateboarded. There were decks with anime chicks on 'em, and one with a little water-ball dude and fireball dude fighting.

Can you discuss how your work moves between digital

and traditional mediums? How do you decide which one to use for a project? Do you have two different workspaces?

Seems like today time is usually the deciding factor on which one to use for a project, but every project starts with a pencil and paper. Mixing the two mediums is always fun, too. Yeah, I do have two different workspaces, one for more traditional work, and one for the computer stuff.

What's your Future Perfect look like?

This has been on my mind a lot since I found out about the project. I would have to say it involves everybody making the future together. There would be lots of

TIME to ROLL

collaboration, people working together to create new and better ways to do things. It's a pretty cheesy answer, but that's how I see it.

That's not cheesy, it makes sense. I'm interested in your visual take on Future Perfect. Can you describe what a perfect world would look like?

The perfect combination between technology and Ewok-style cities.

What would be a Future Perfect situation to make art?

I have no clue to be honest; I'm pretty happy with the situation right now.

Right now scientists are working on three-dimensional DNA printers, the idea being that the printer will be able to "print" new life forms using amino acids. Potentially we could shoot printers into space, land on habitable planets, and then populate those planets with printer-made humans, plants, and animals. Check out Singularity University, funded by NASA and Google if you want the details, because I didn't make that up. If NASA came to you and said, "Corey, we'd like for you to pick the color scheme for New Portland, a settlement of printed people, in a distant galaxy," how would you go about the assignment?

First off…woah! Welcome to the future. NASA is coming up with some crazy stuff. That would be an interesting assignment. Tree green is the first color that pops into my head, so I'd probably cross that one off the list. Then I'd probably try and find a set of colors that defines Portland. Colors from the Portland flag [blue, green, yellow, and white], Blazers colors [black, red, silver, white] or the colors from the "Made in Oregon" sign [yellow, white, red, green].

How did the Super Daily Doodle project get started?

Inspired by similar projects, where people

IT WAS A GOOD DAY.

make something daily, I decided to start my own. It's a blast and I don't plan on stopping anytime soon.

It's a way for you to visualize what you're doing that day, like going to see a movie or maybe just relaxing with friends. Making a daily piece is a nice way to get your ideas out of your head. What is your experience with the Super Daily Doodle? Does it inform your other work?

Heck yes it does. Doodles have inspired zines, paintings, and other projects. The experience has been that there are no limits to the project, which can be amazing and frustrating. The project gives me an opportunity to experiment, fail, and put my random thoughts out there for the world to see.

Your Super Daily Doodle project uses color that is easy on the eye: low-chroma purple, gray benday dots, and

washed-out blacks, yellows, reds, and blues. It is a truly relaxing palette. How important are color choices to you? Do you try and set a specific mood with color, or is your process more experimental?*

If I know the mood I want for a certain piece or doodle I will definitely try to set it with the color. As you've noticed, most of the time it's a relaxing palette to match the chill drawings.

Which artists working now do you think are interesting?

Tons of artists make awesome work. A couple I dig are Michael DeForge [kingtrash.com], Trevor Basset [brevortasset.com] and my buds Curtis Sorensen [no website :(] and Bryce Pedersen [brycep.tumblr.com].

Your work is printed in this book, but some of your work is most accessible on the internet. GIFs, for instance,

40

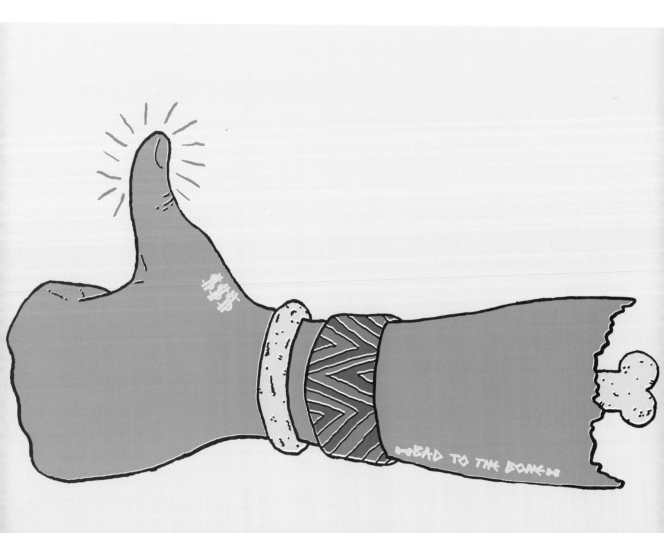

realize their full GIF potential on a computer. Does the ephemerality of the screen and anonymity of the internet give you more freedom?

Yeah, I would say so. GIFs are short and sweet and you have tons of freedom when making them. Growing up in the 90's and 00's I've seen the internet evolve, and animated GIFs have always been appealing. I love the texture the limited color palette creates; it reminds me of my youth, and the short loops you can create with GIFs are always fun to make.

Do you listen to music while you're working?

Totally, there is always something going on in the background. Most of the time it's music, sometimes it's a movie. It helps me work better and puts random thoughts into my noggin.

What groups are you into?

J Dilla, Madlib, Air, Of Montreal, David Bowie, Flying Lotus, Wu-Tang Clan, and Wavves to name eight. Also "Playing with the Boys" by Kenny Loggins is a super sweet song. It's guaranteed to get you pumped.

I was checking out your blog, and you're an intellectually curious person. Does the stuff you post on your blog find its way into your work?

Yeah, a lot of the time that's why I blog. I'll post a clip from a movie I like, a picture of a zine somebody made, or an album I'm into hoping it will spark an idea for a drawing I'll do later that day.

Fig.16

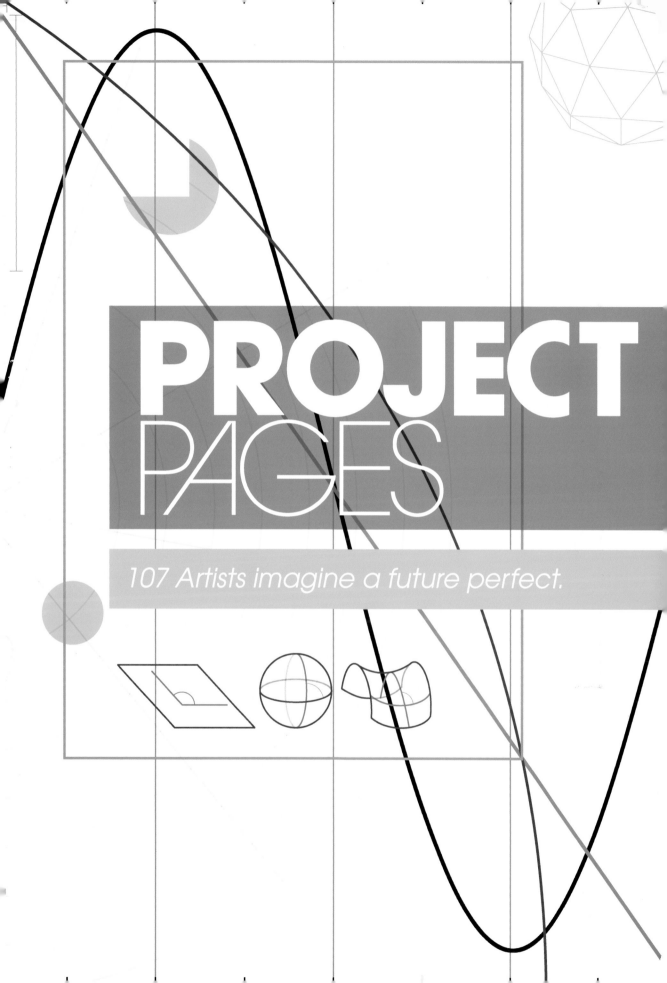

PROJECT
PAGES

107 Artists imagine a future perfect.

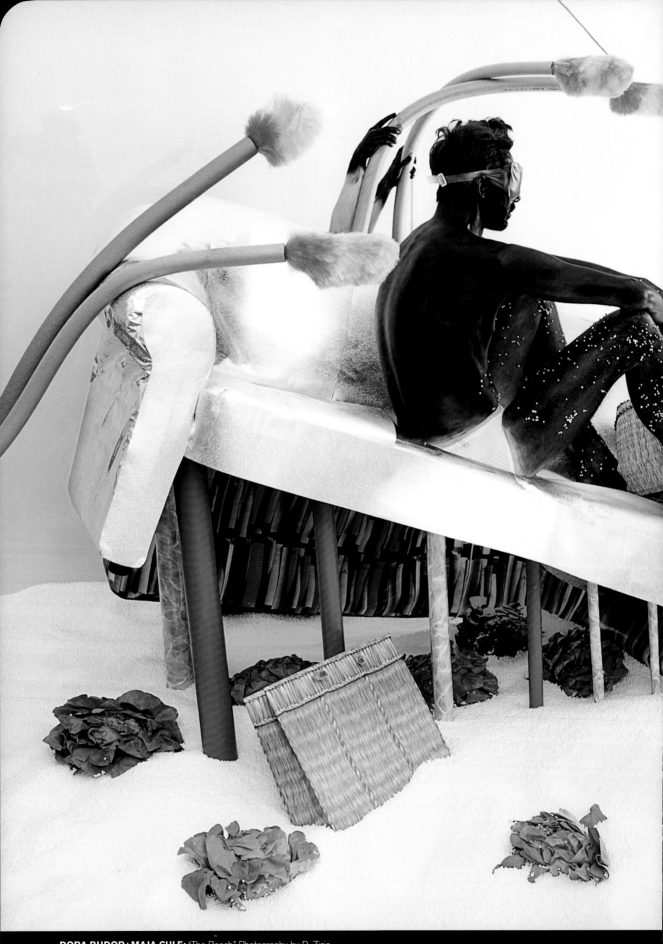

DORA BUDOR+MAJA CULE: "The Beach," Photography by D. Zizic

BRIAN VU: (Left page) "Believer," Collage. 8.5" x 11".
(Right page) "Stay Gold," Collage. 8.5" x 11".

MARK SARMEL: "Miss Vengeance," Digital. 11" x 17". **SARMEL.COM**

TIME

March 18th 19

...n system...
...y prepared four
...nsors, each of which
... in one form or another.
...was also secretly scouting
... Disney theme park. In
...orld" was announced, with

...ntertainment Empire,
Bob Thomas, 1998

...his Disneyland series to u...
...yland Park, an id...

66

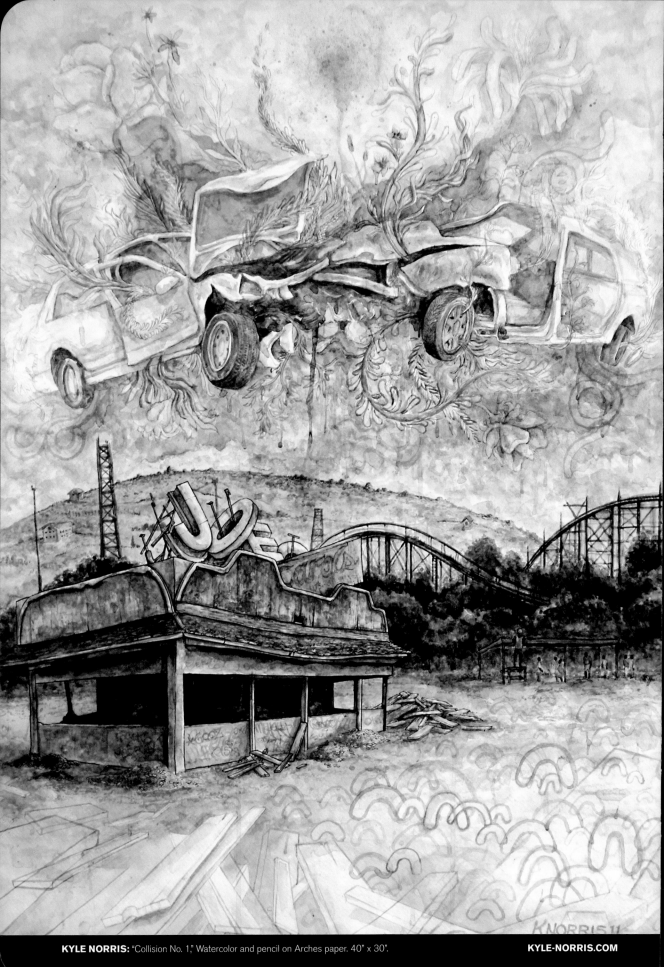

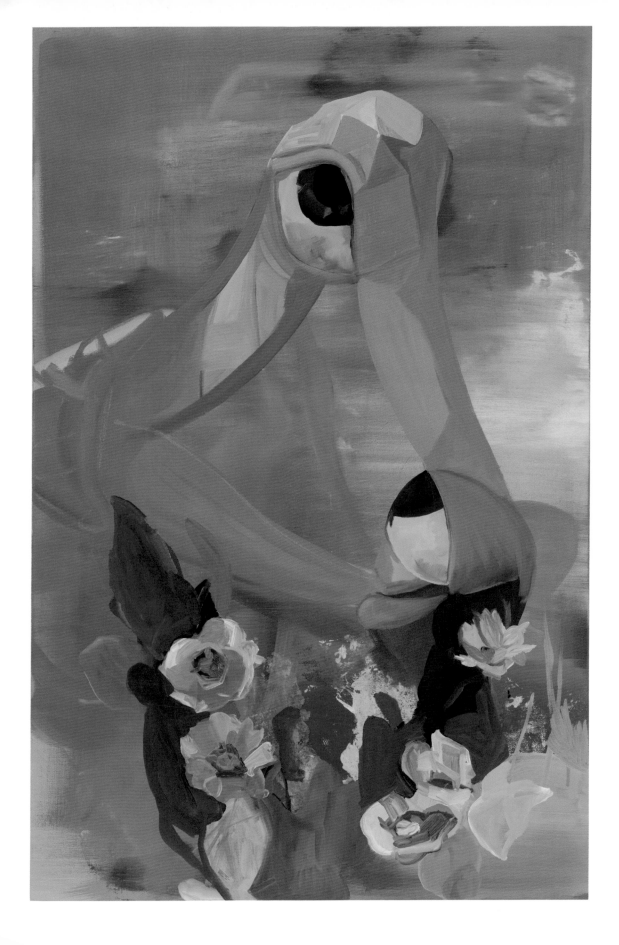

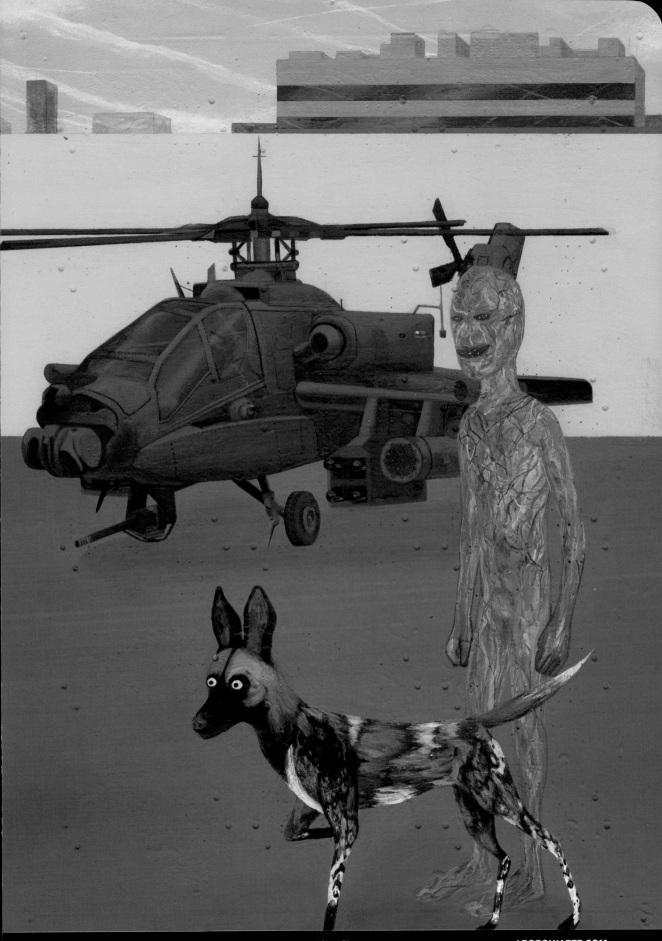

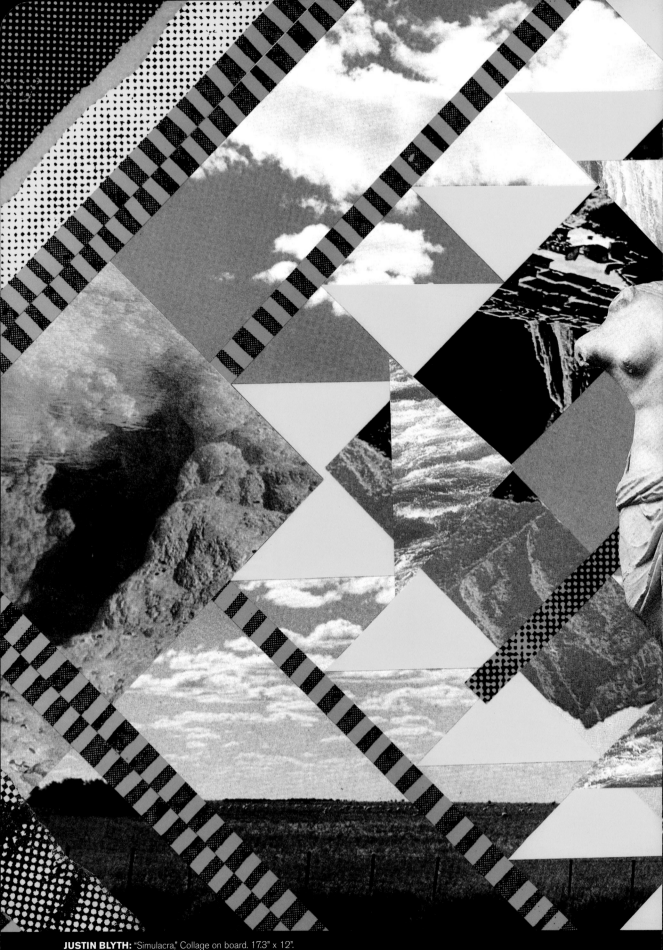

JUSTIN BLYTH: "Simulacra," Collage on board. 17.3" x 12".

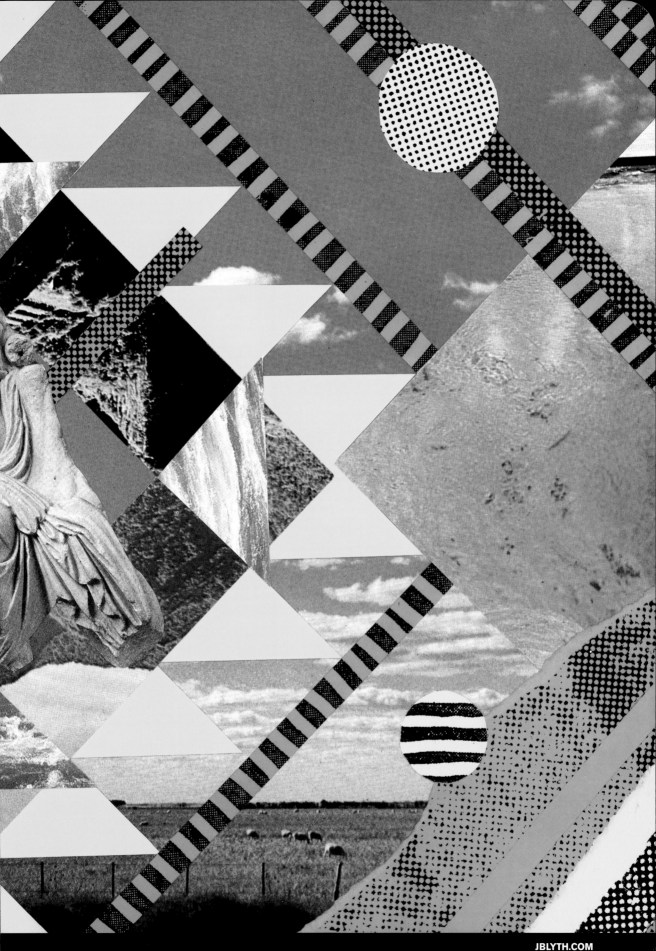

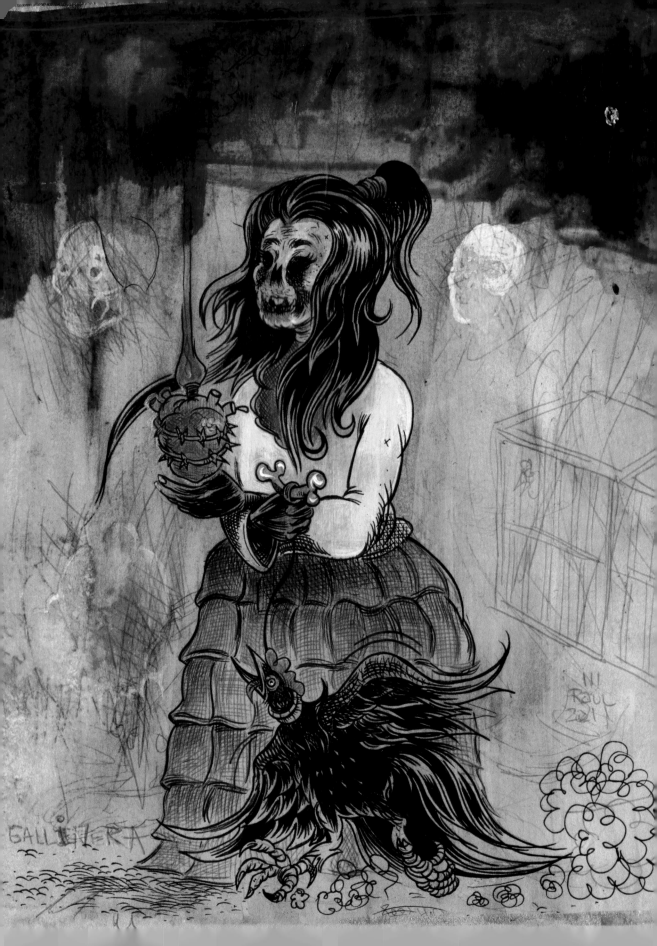

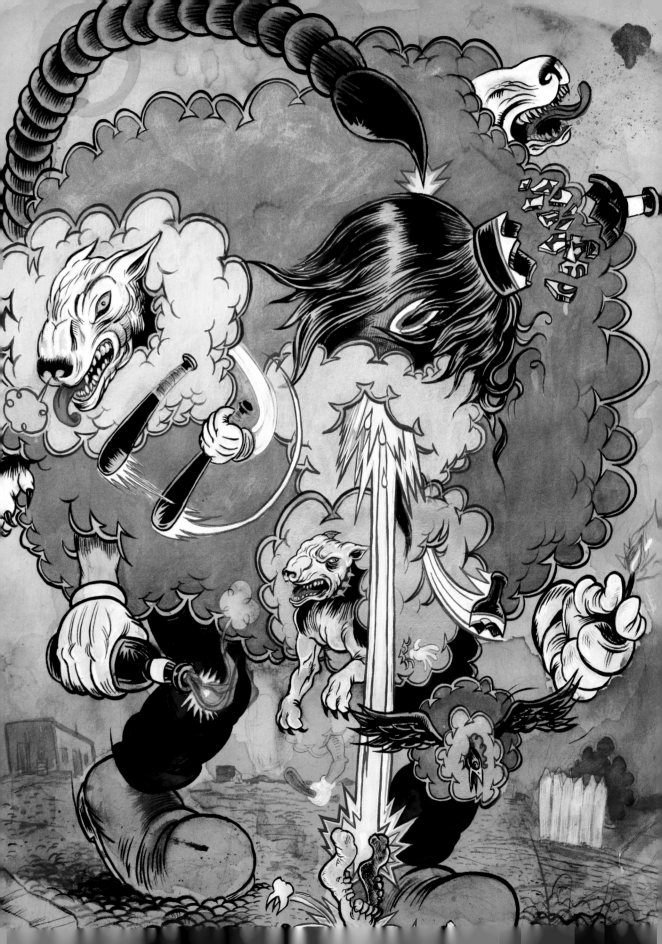

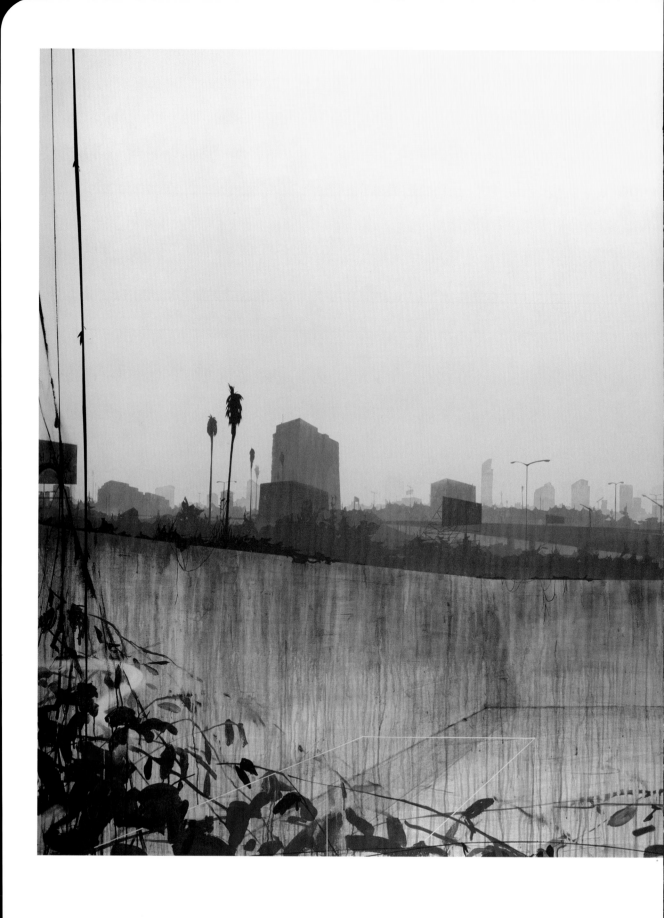

ROBERT MINERVINI: "Tomorrow Dreams," 2011. Acrylic on canvas. 75" x 126" Courtesy of Marine Contemporary

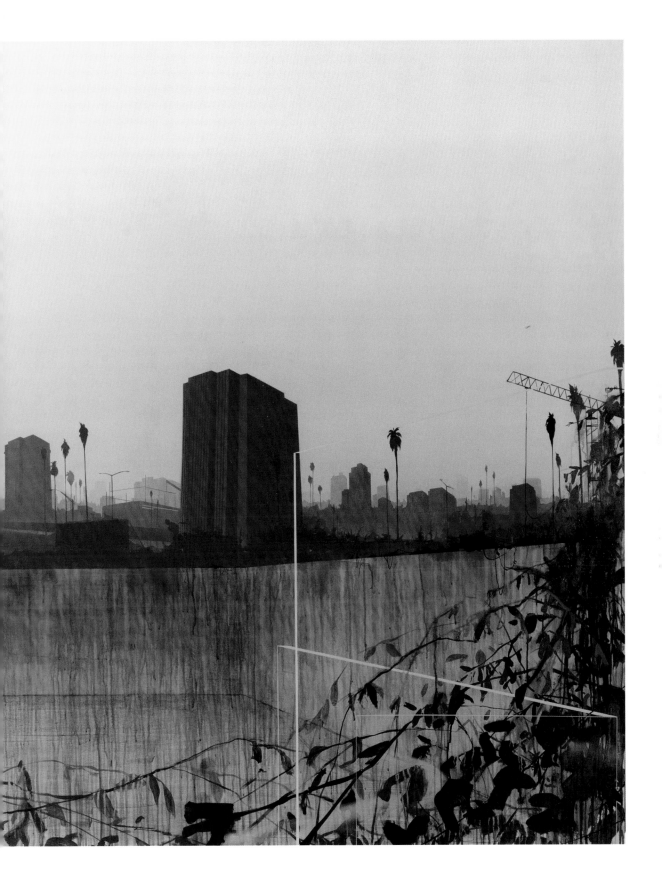

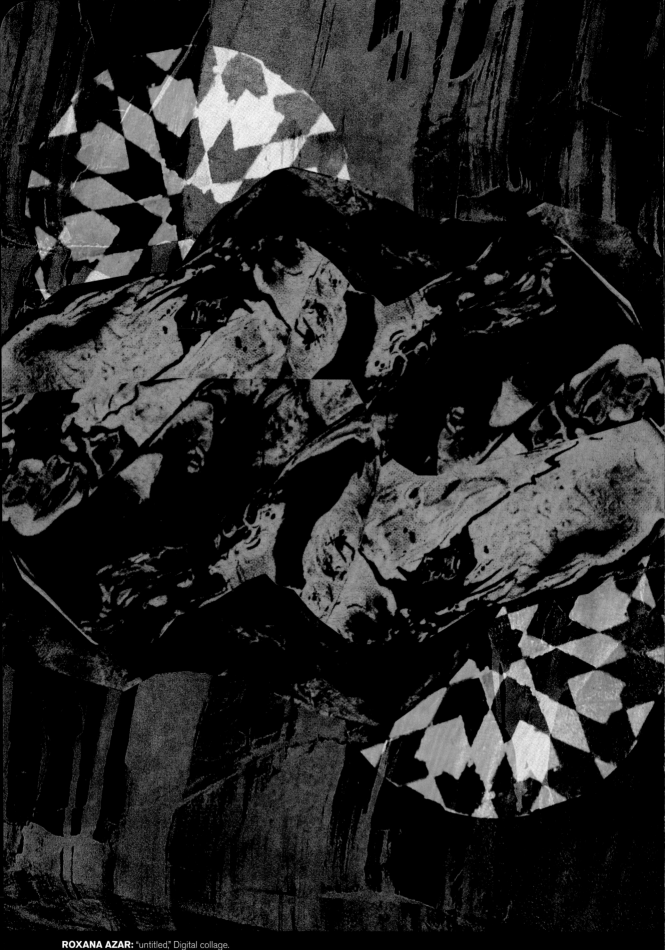

ROXANA AZAR: "untitled," Digital collage.

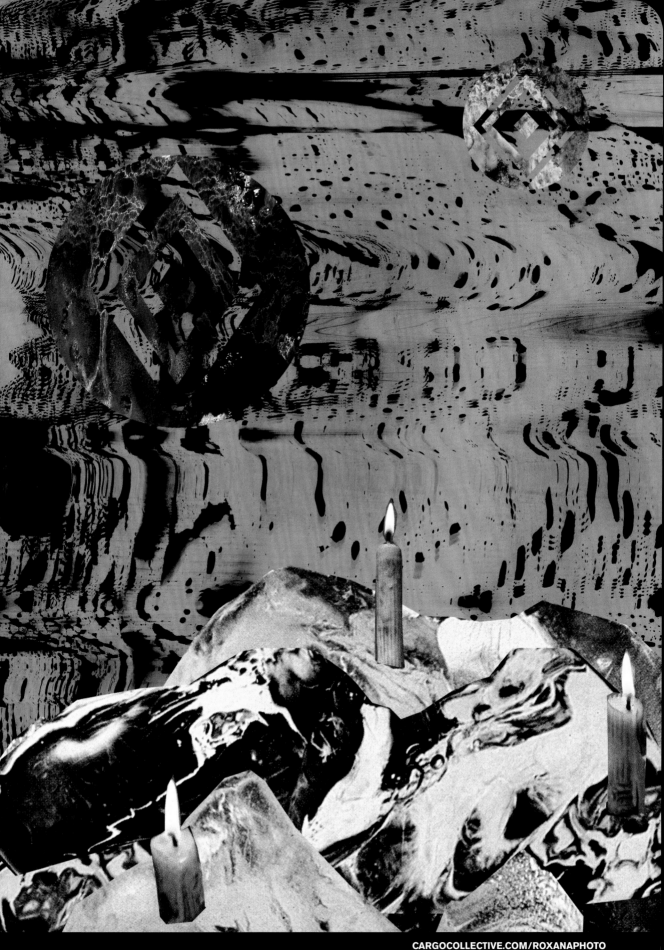

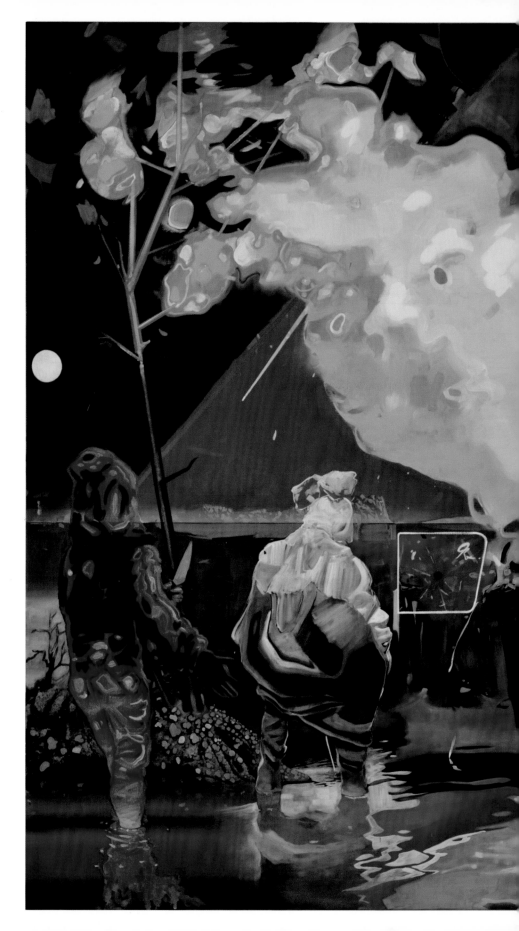

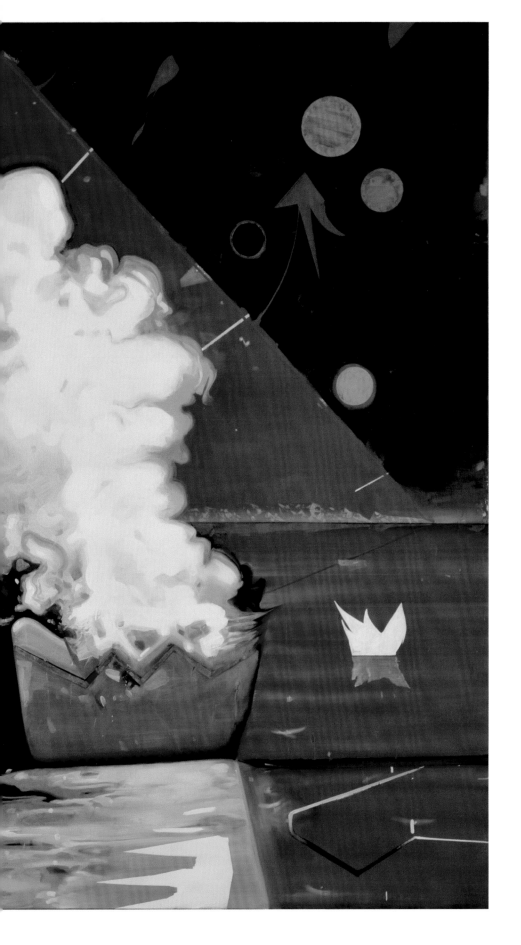

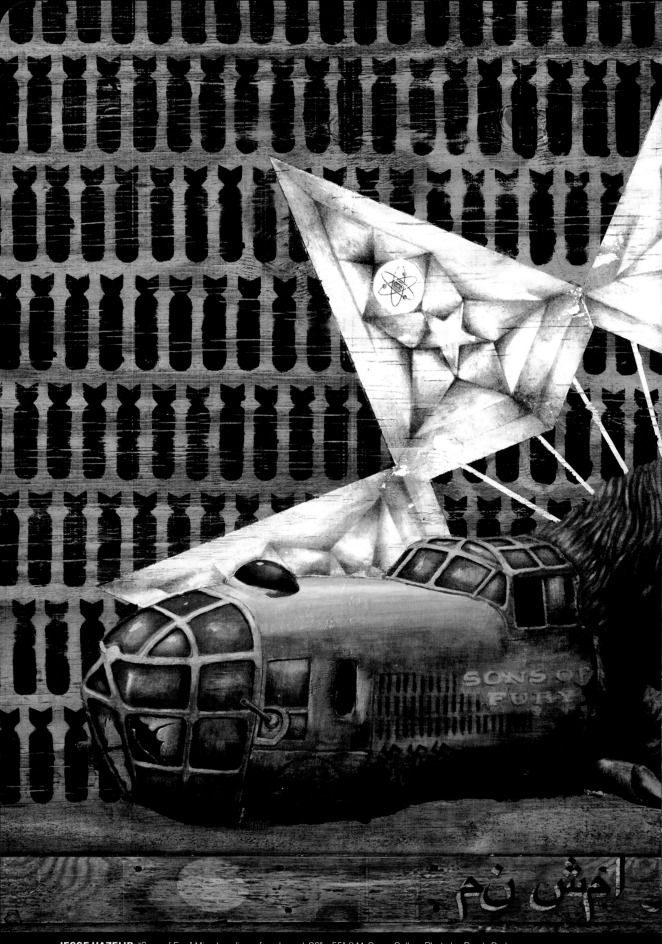

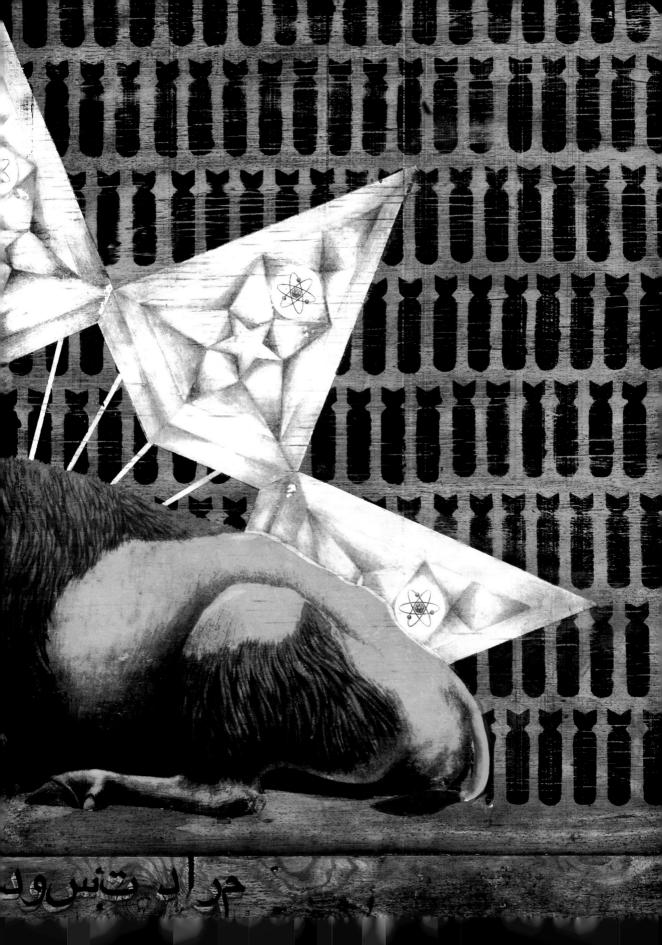

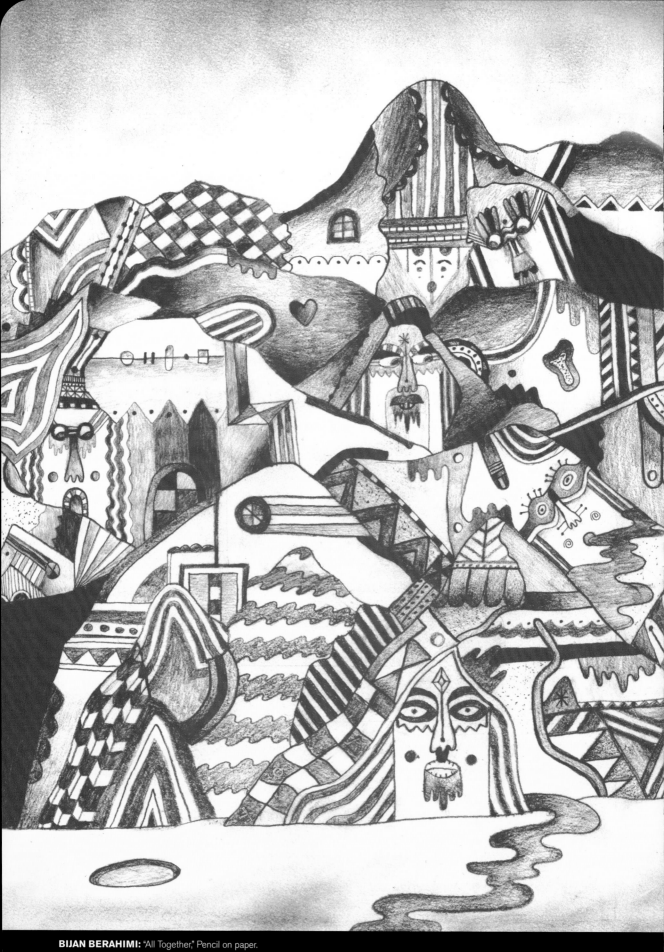

BIJAN BERAHIMI: "All Together," Pencil on paper.

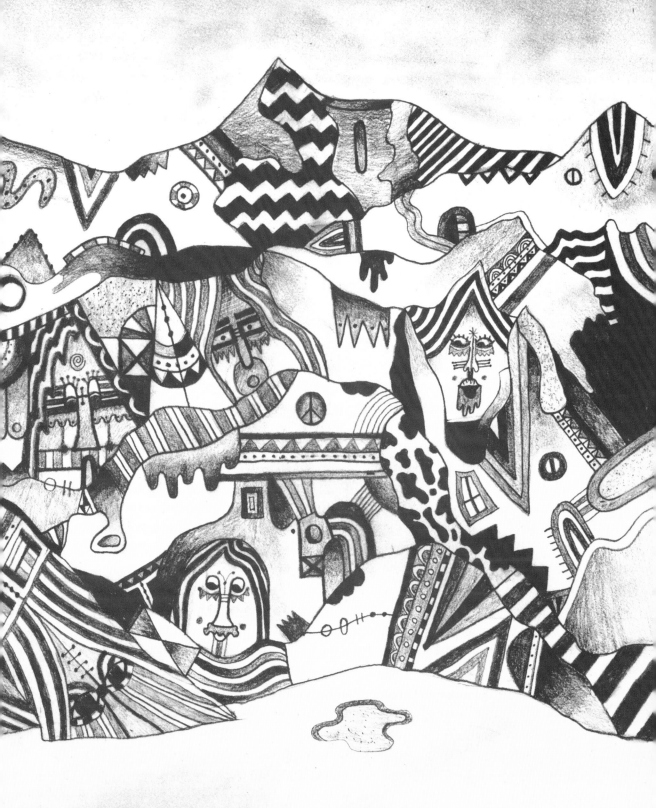

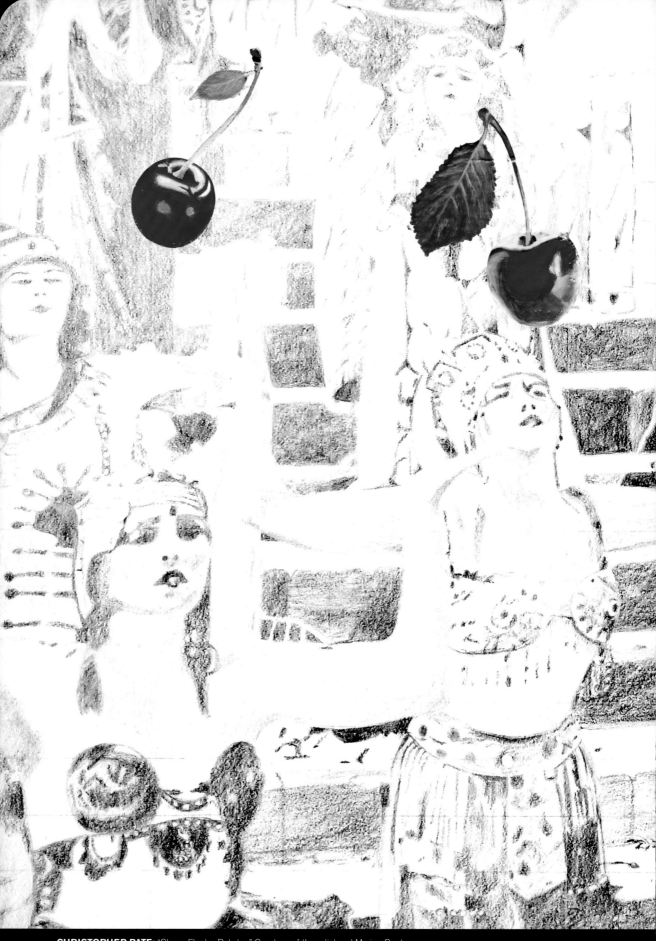

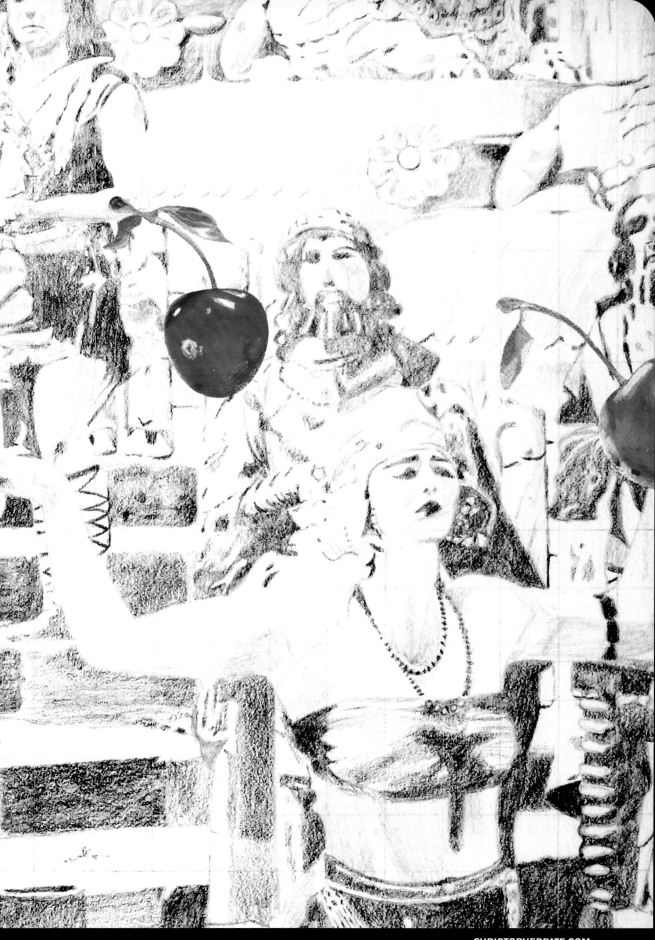

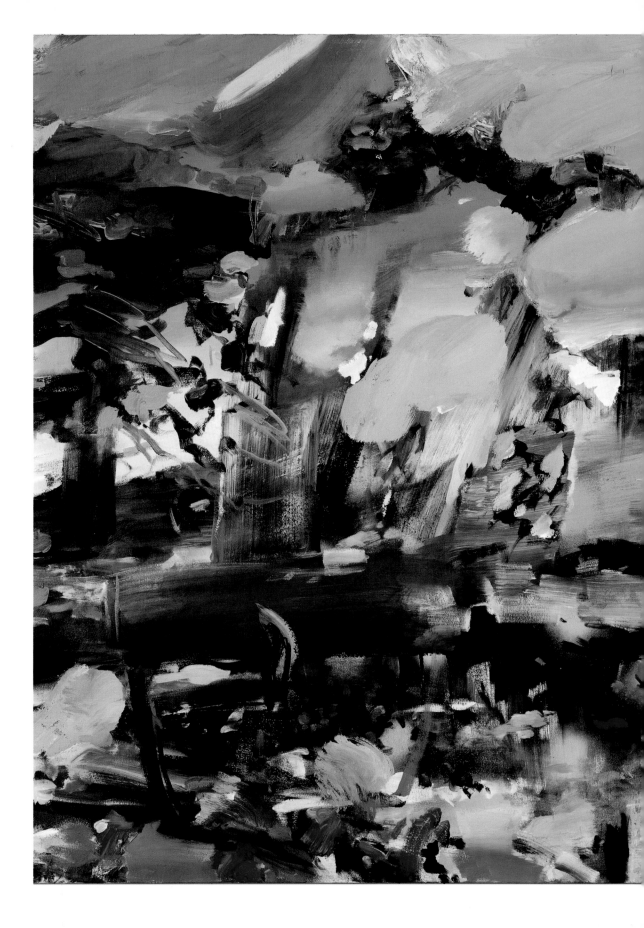

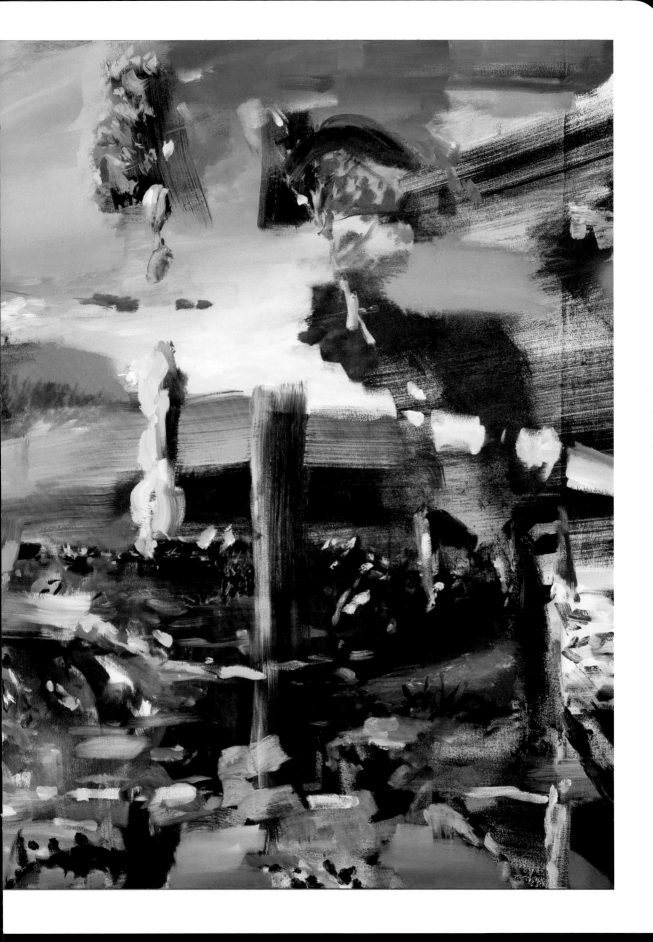

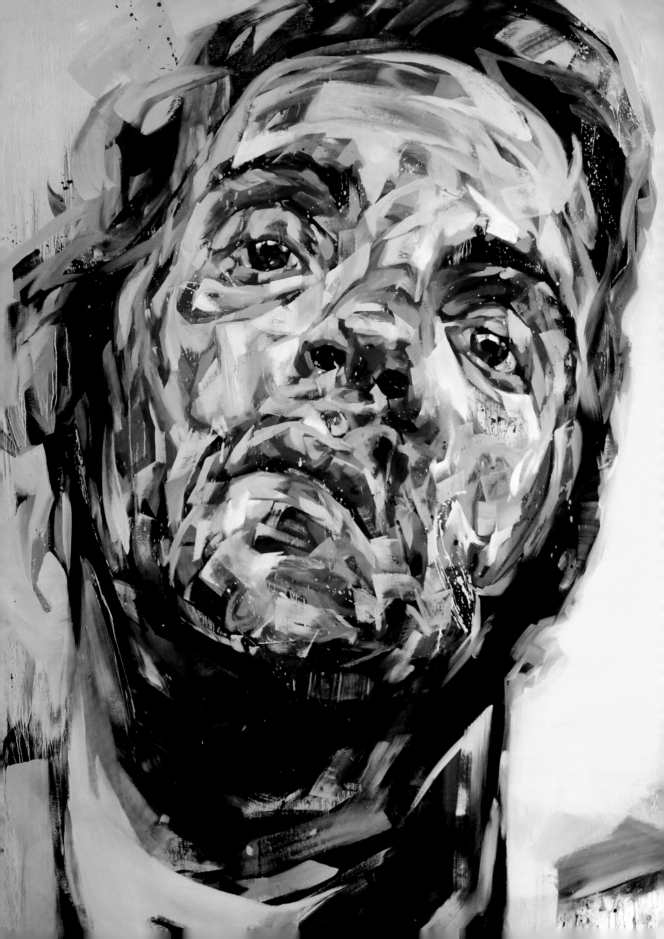

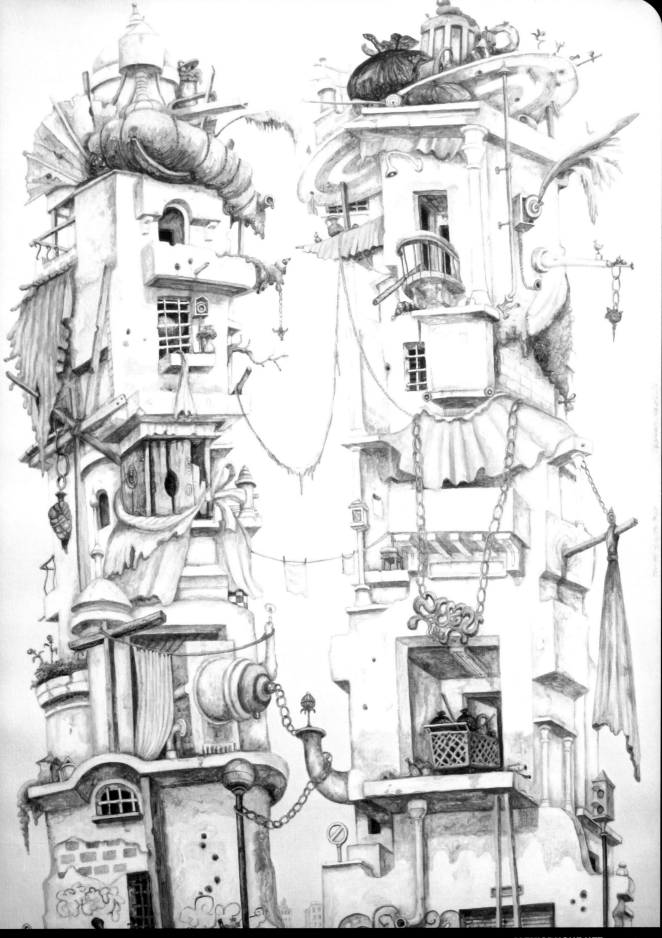

YASSY GOLDIE: "Lepardini CROTCHshotWhoof on the Boston Sky Line," Dimensions vari-

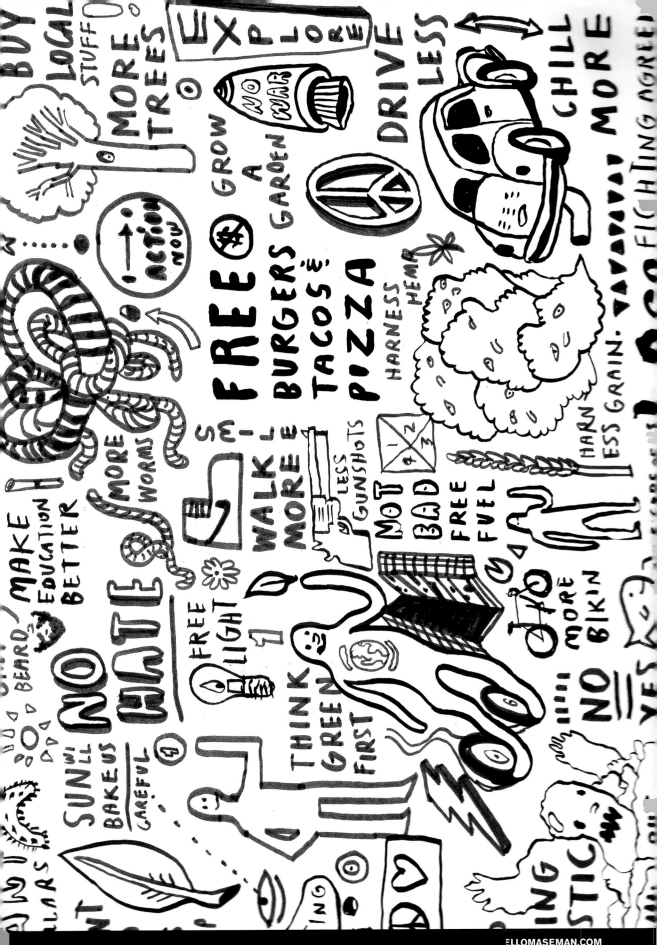

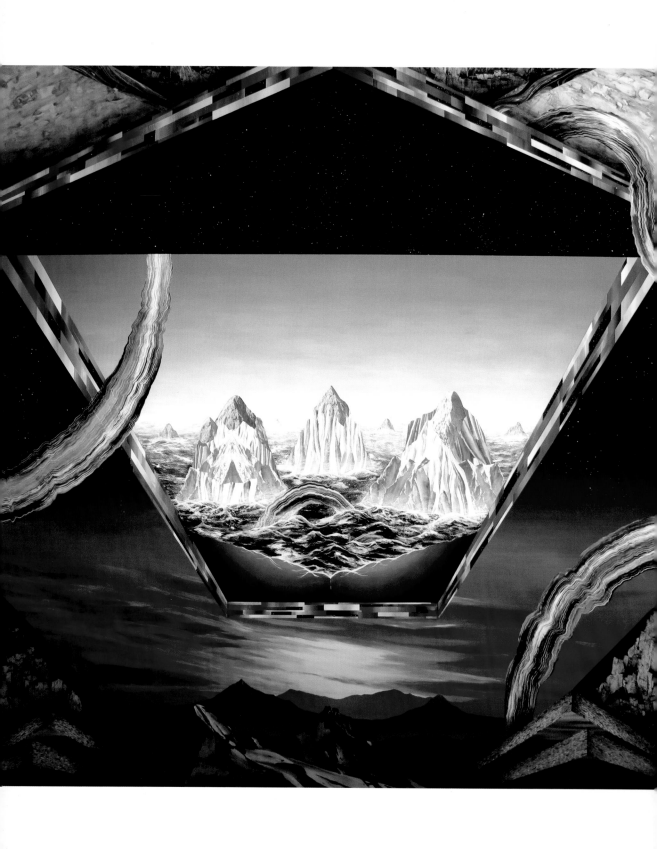

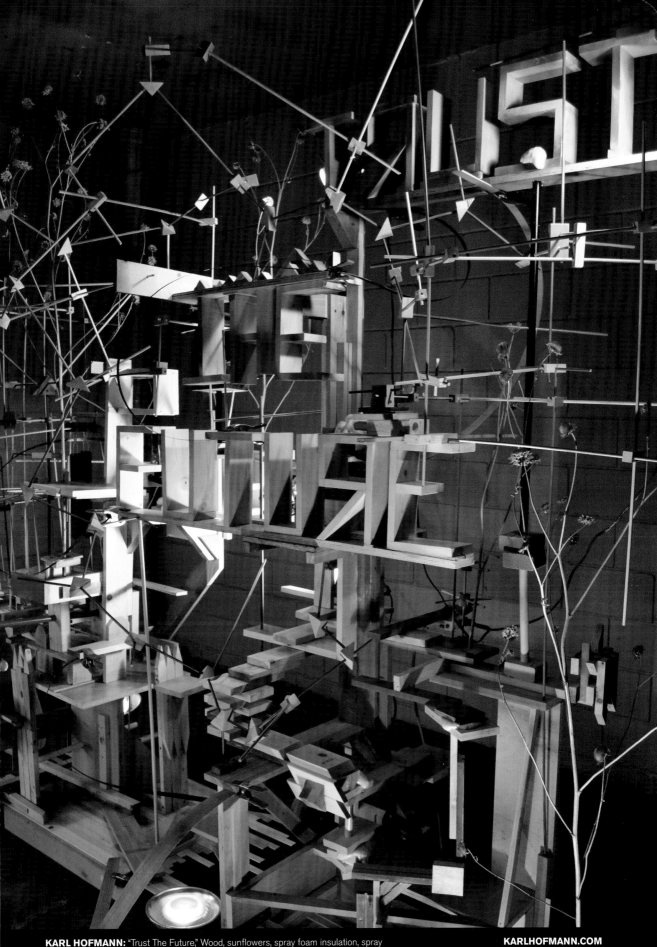

KARL HOFMANN: "Trust The Future." Wood, sunflowers, spray foam insulation, spray paint. 8' x 14' x 6'.

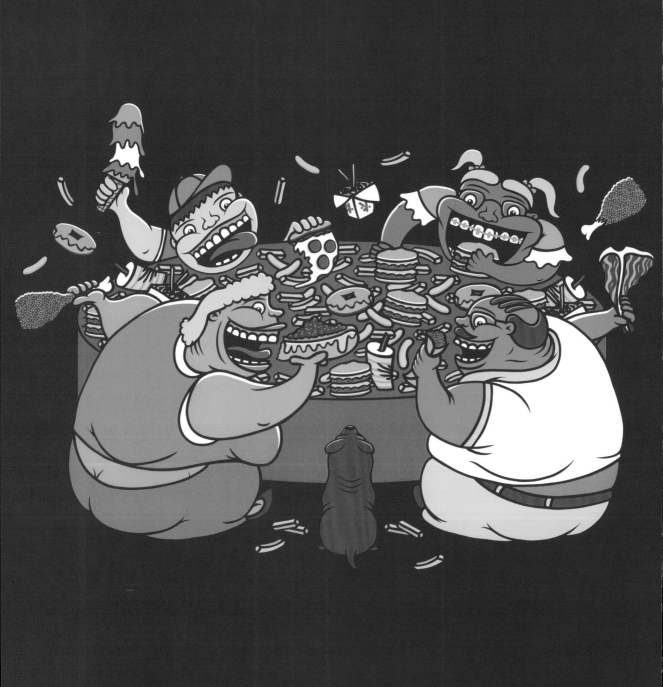

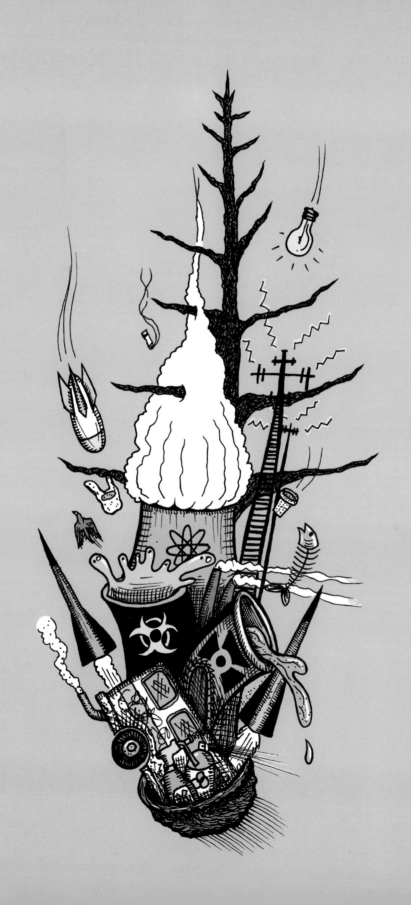

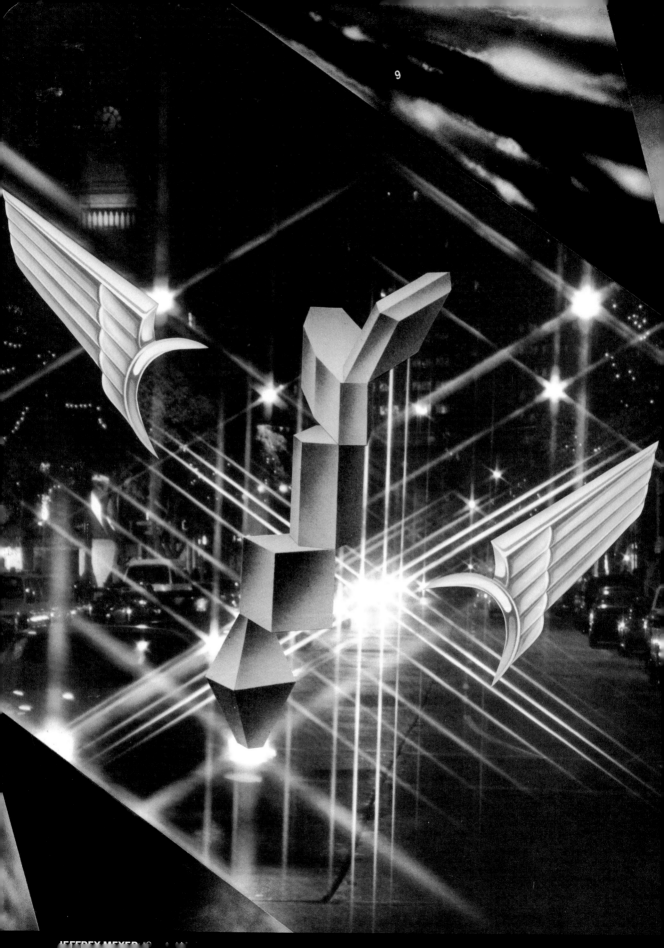

JEFFREY MEYER

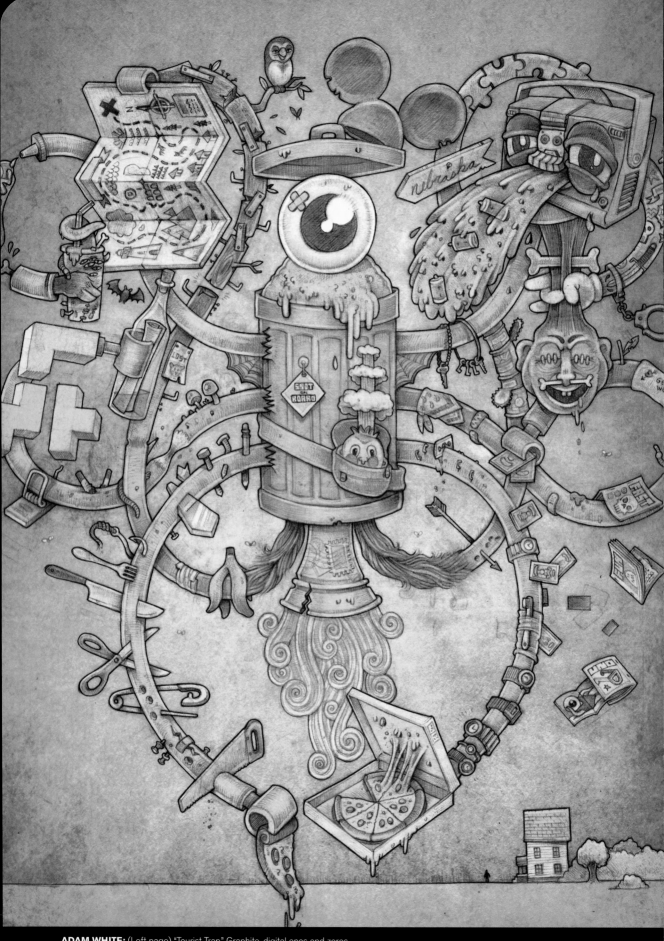

ADAM WHITE: (Left page) "Tourist Trap," Graphite, digital ones and zeros.

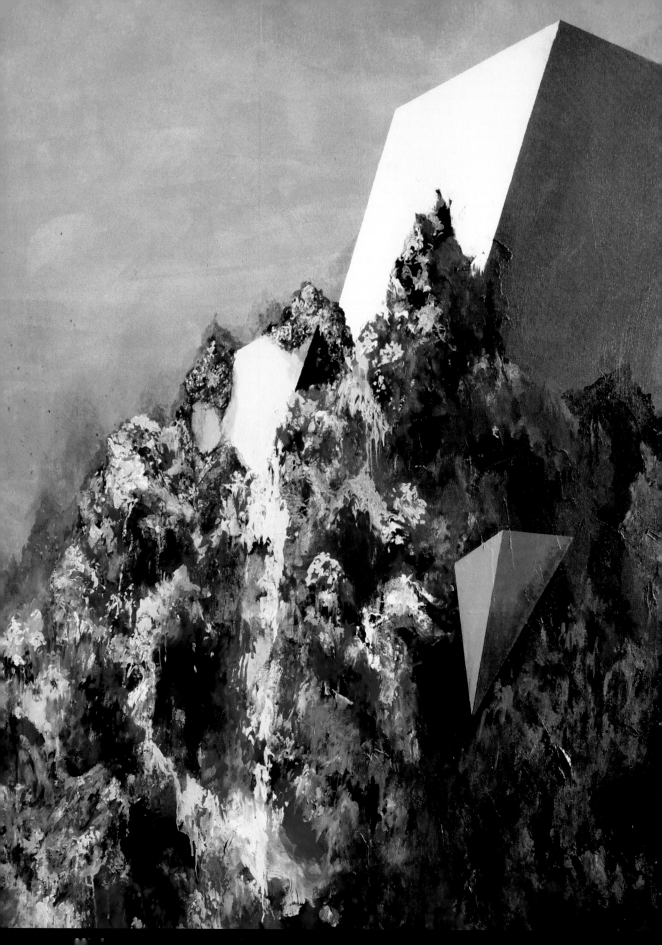

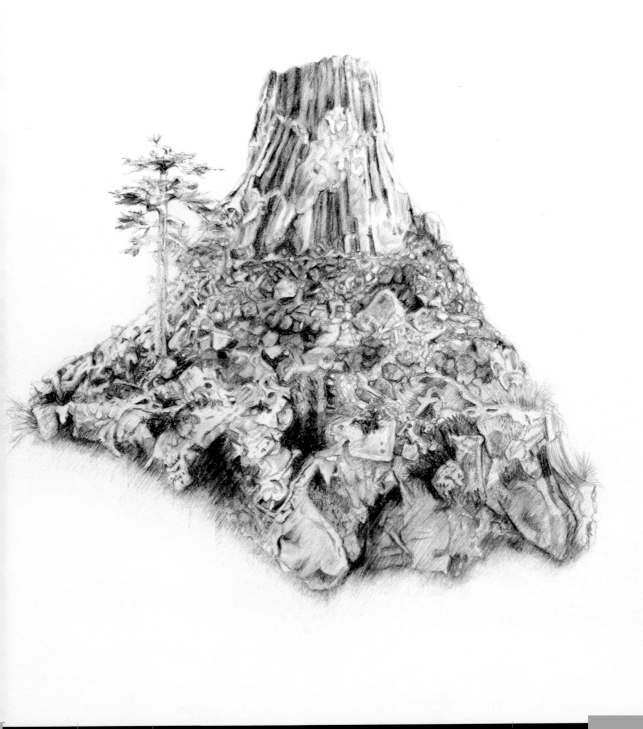

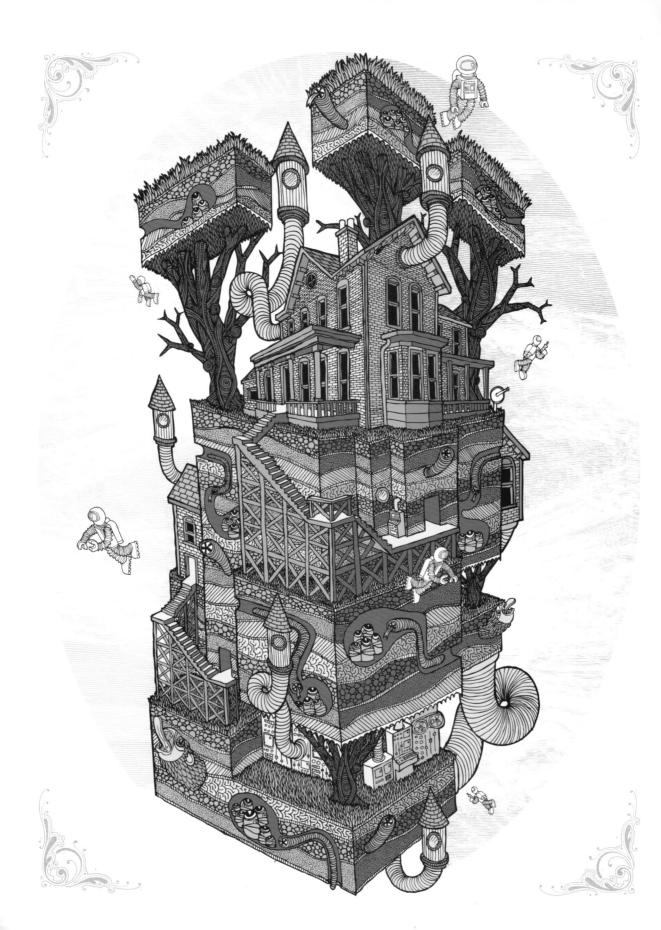

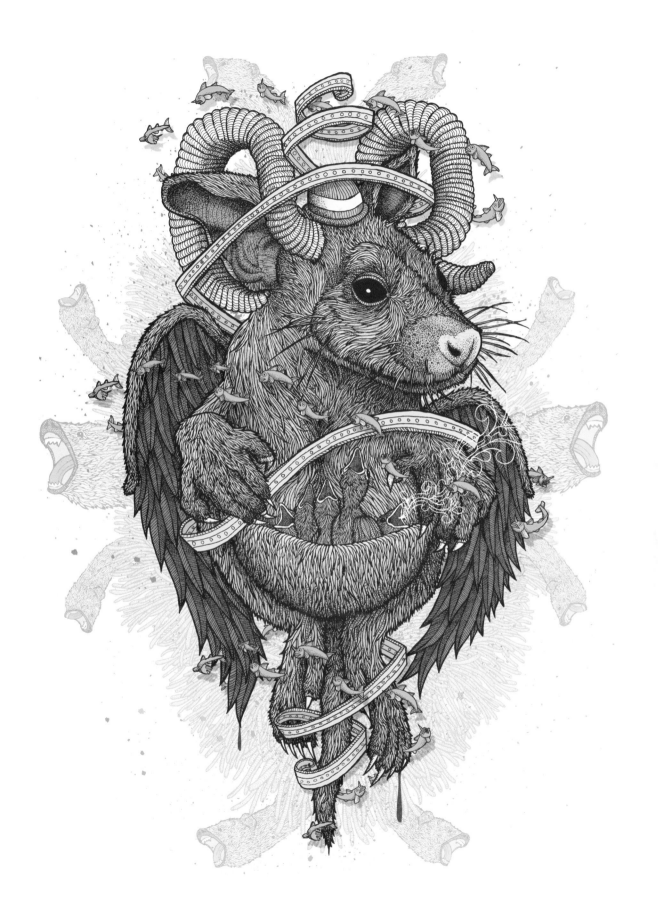

STEVEN RIDDLE: (Left page) "Tailored Assembly," 2010 Gouache, acrylics, marker, collage on paper. 13 × 11".
(Right page) "Crowning Touch," 2010. Gouache, acrylics, collage on paper. 12 × 18".

NATURAL SYSTEMS

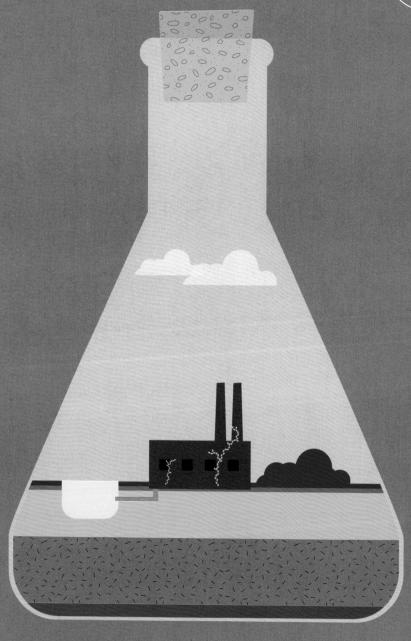

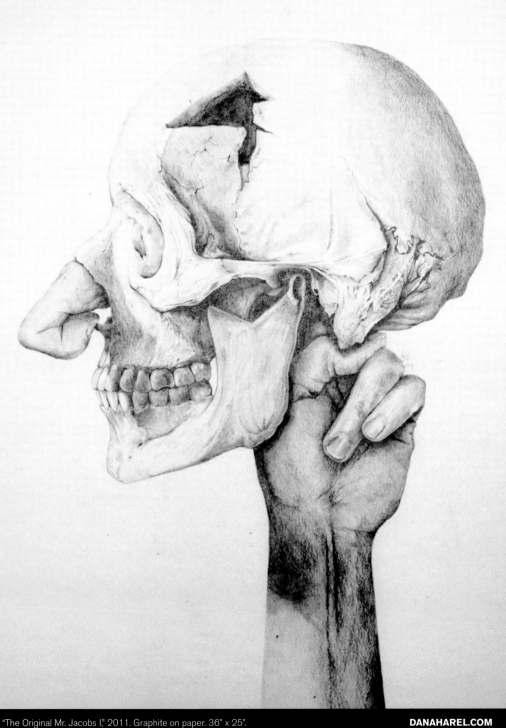

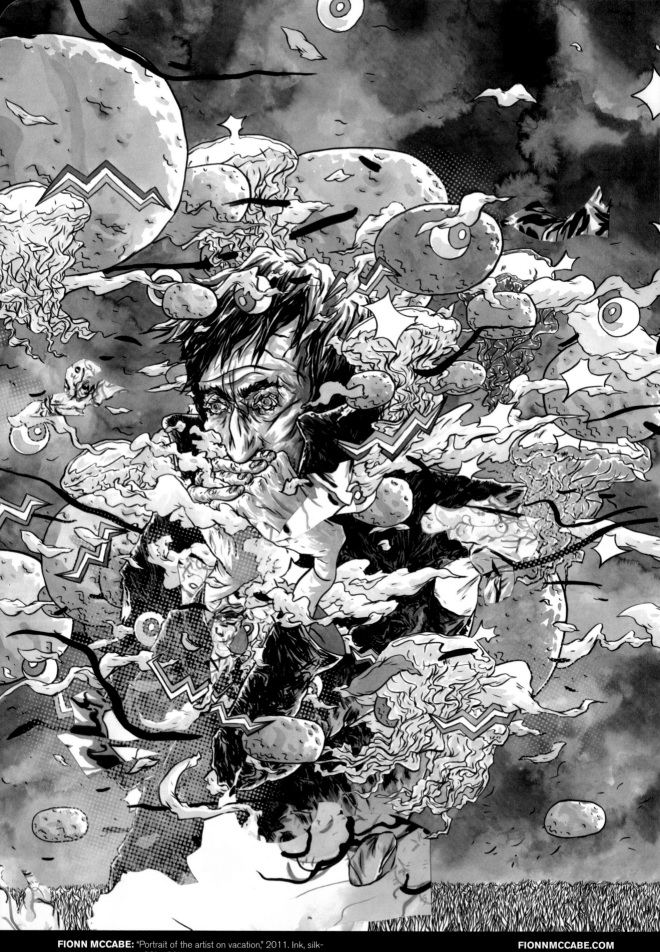

FIONN MCCABE: "Portrait of the artist on vacation," 2011. Ink, silk-screen and cut paper. 22" x 30".

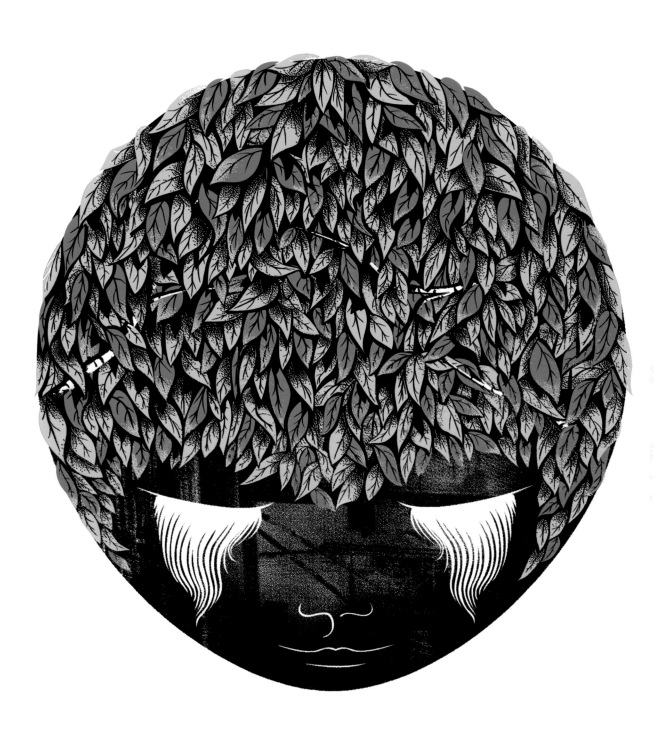

gradually

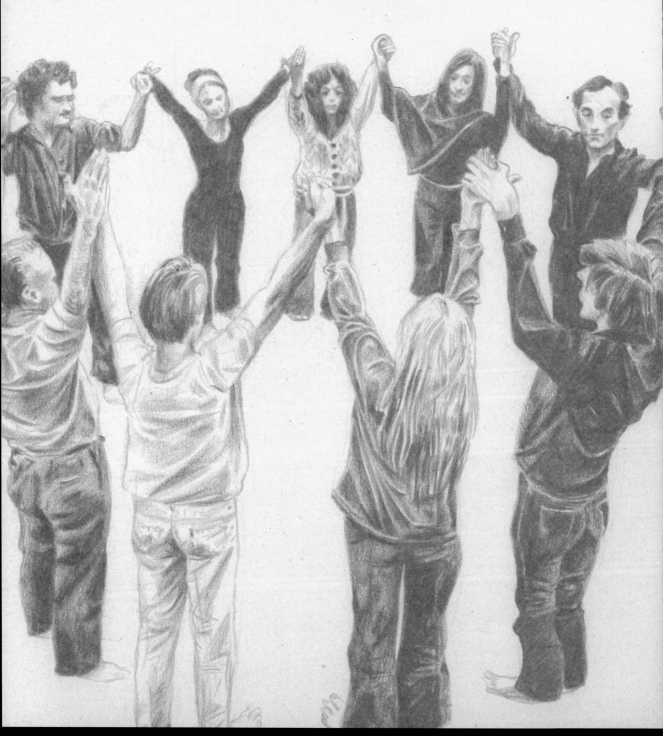

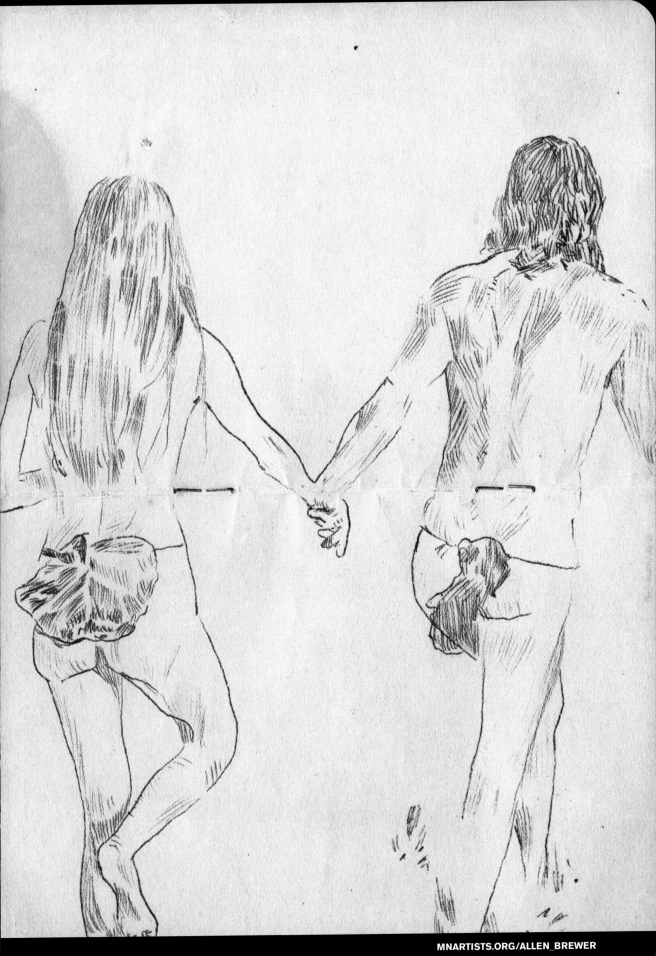

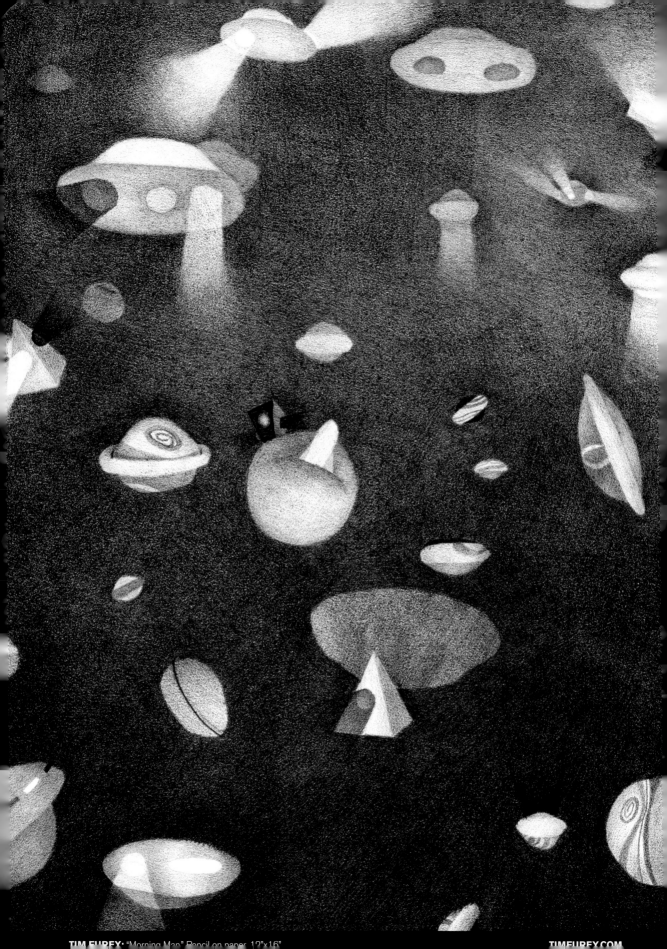

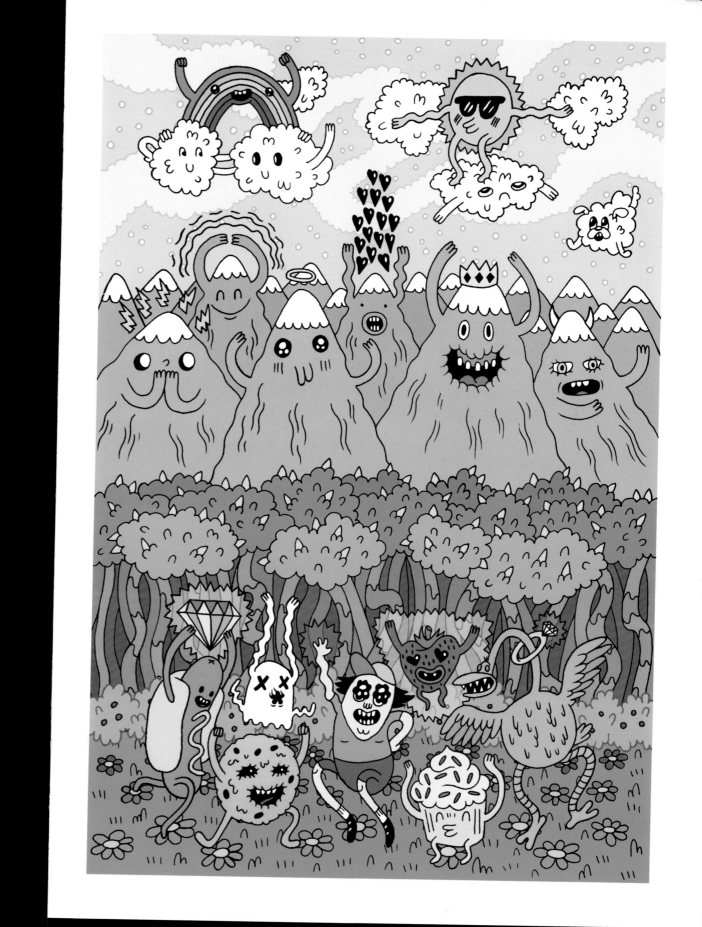

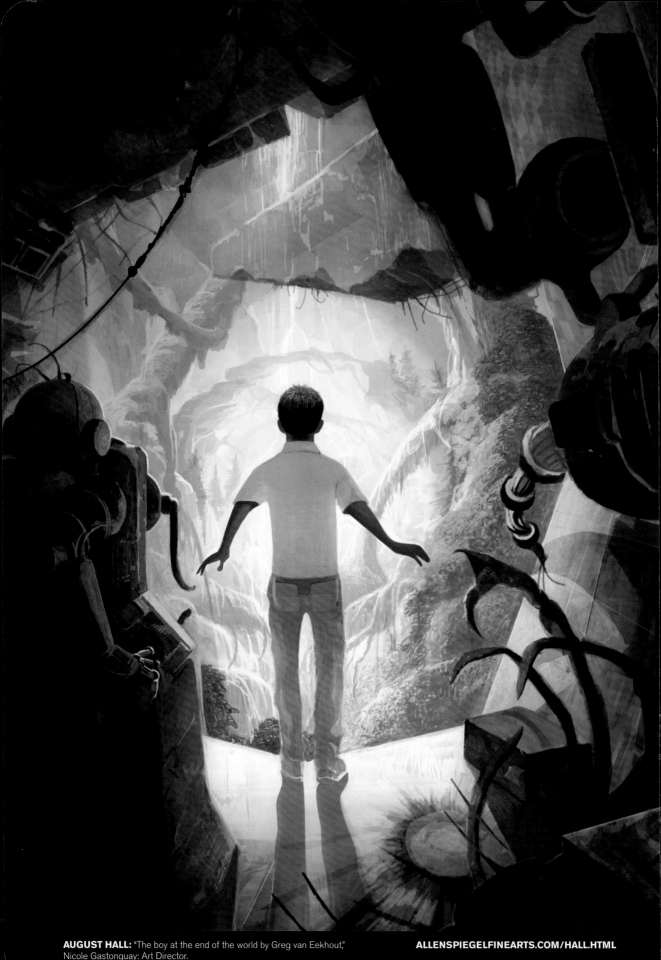

AUGUST HALL: "The boy at the end of the world by Greg van Eekhout,"
Nicole Gastonguay: Art Director.

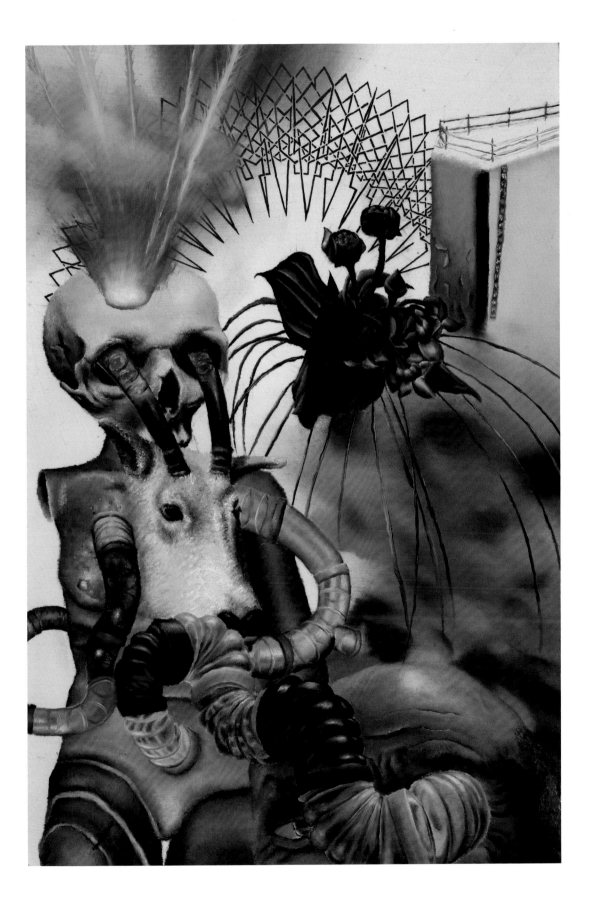

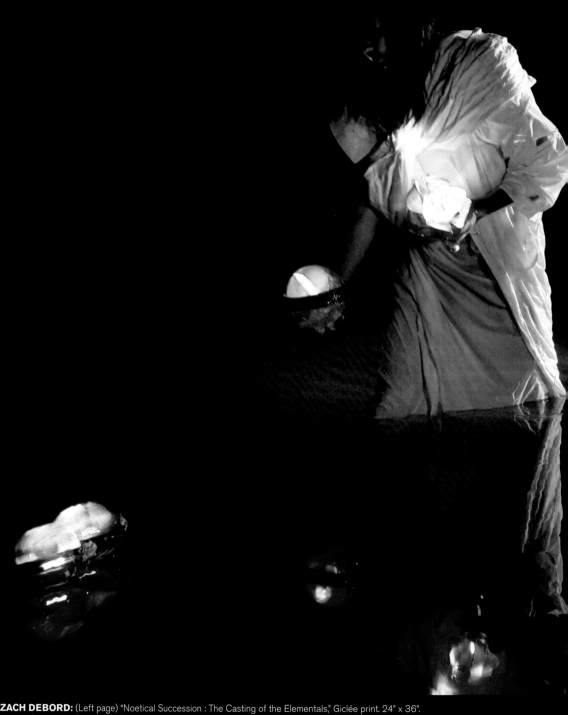

KIM & ZACH DEBORD: (Left page) "Noetical Succession : The Casting of the Elementals," Giclée print. 24" x 36".
(Right page) "Noetical Succession : The Substance and the SuperSubstance," Giclée print. 24" x 36".

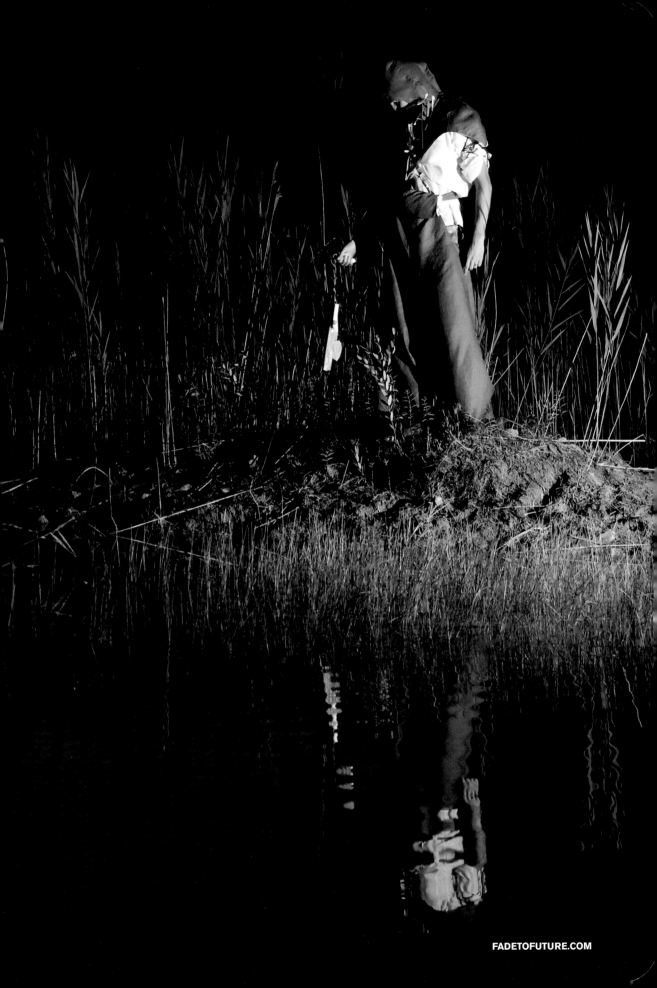

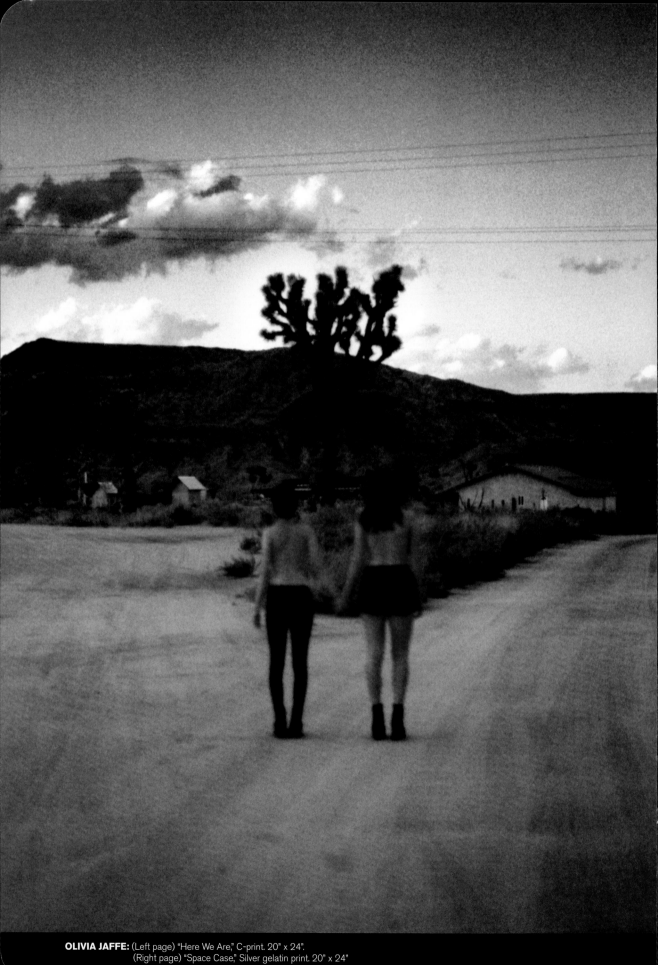

OLIVIA JAFFE: (Left page) "Here We Are," C-print. 20" x 24".
(Right page) "Space Case," Silver gelatin print. 20" x 24"

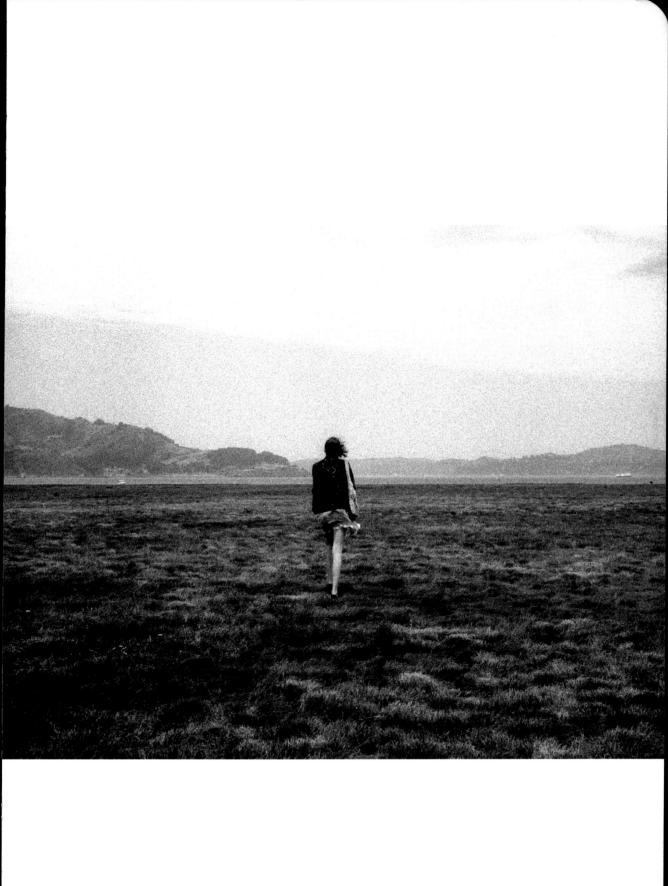

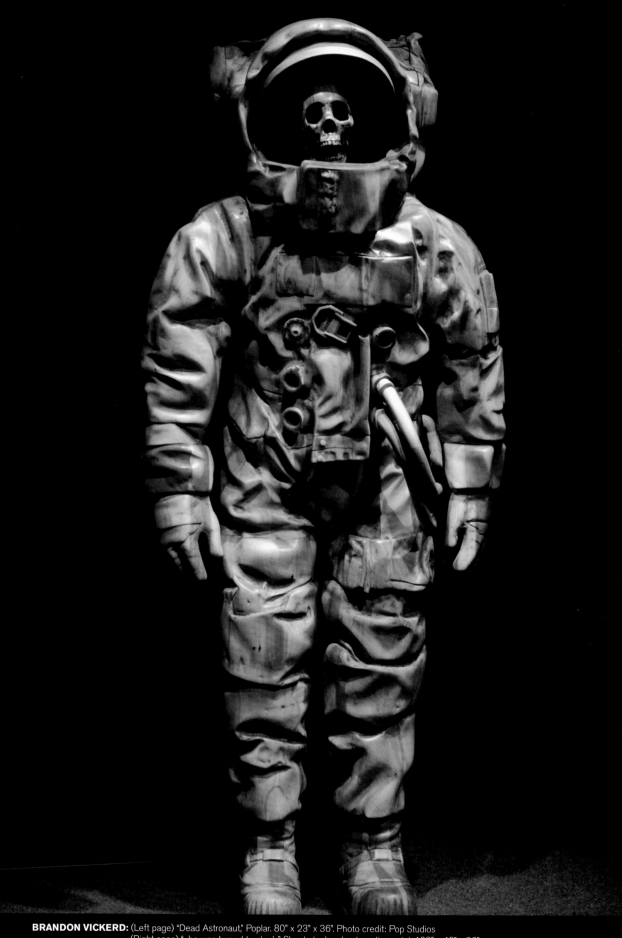

BRANDON VICKERD: (Left page) "Dead Astronaut," Poplar. 80" x 23" x 36". Photo credit: Pop Studios
(Right page) "...he was turned to steel..." Sheet steel and automotive paint. 108" x 48" x 36".

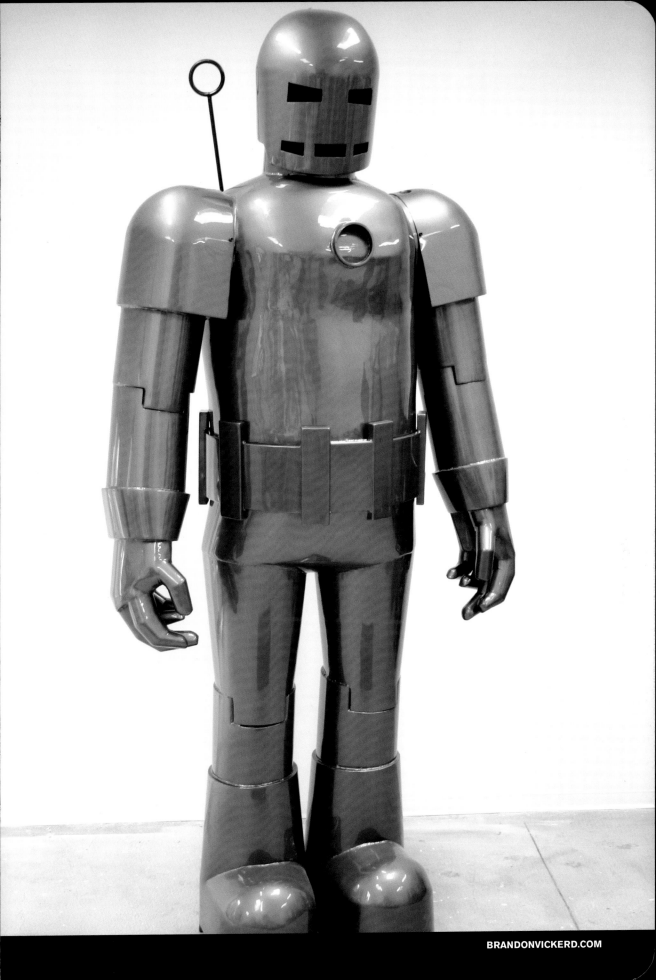

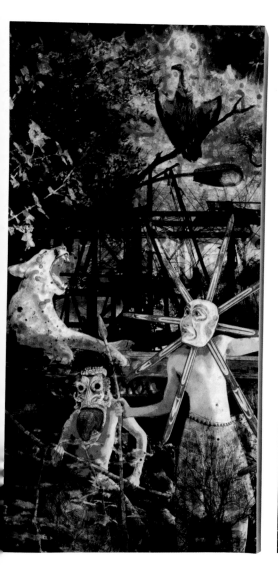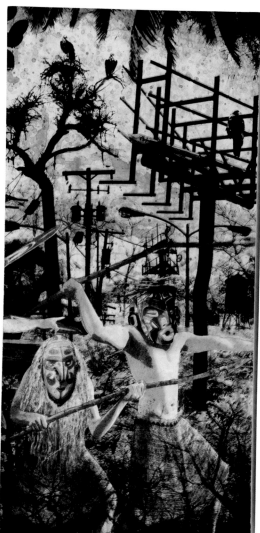

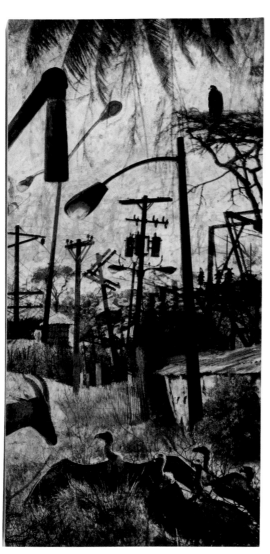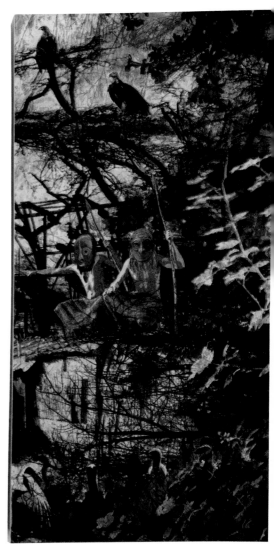

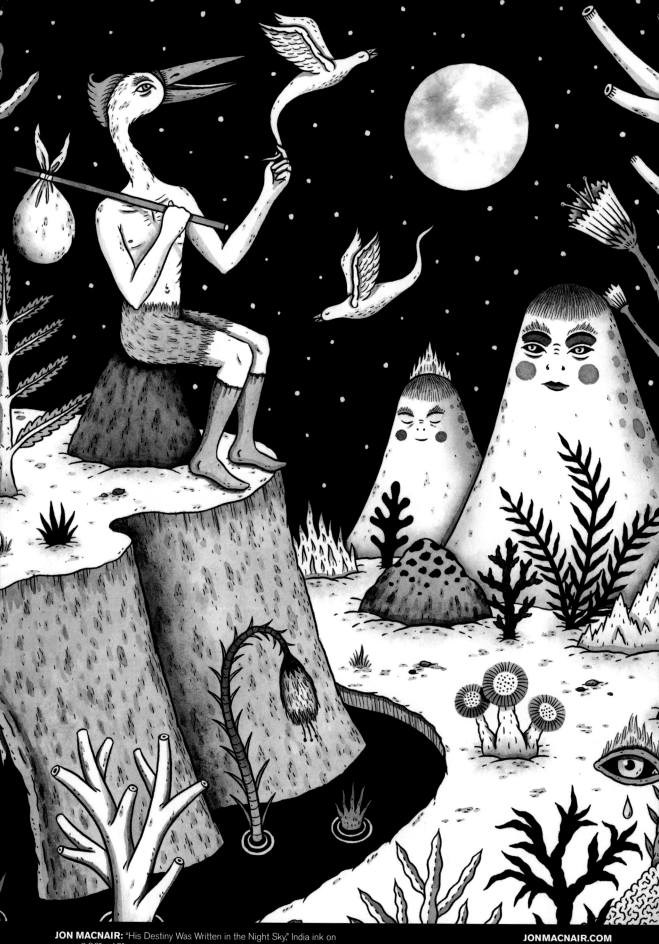

JON MACNAIR: "His Destiny Was Written in the Night Sky," India ink on paper. 9.36" x 12".

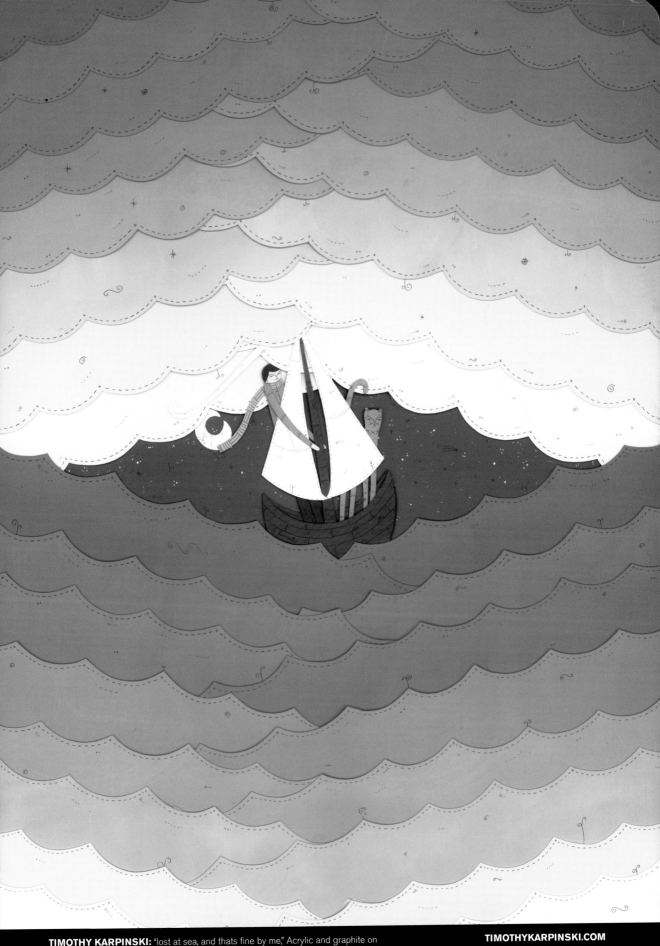

TIMOTHY KARPINSKI: "lost at sea, and thats fine by me," Acrylic and graphite on handcut paper. 21" x 28". Courtesy of Together Gallery

TIMOTHYKARPINSKI.COM

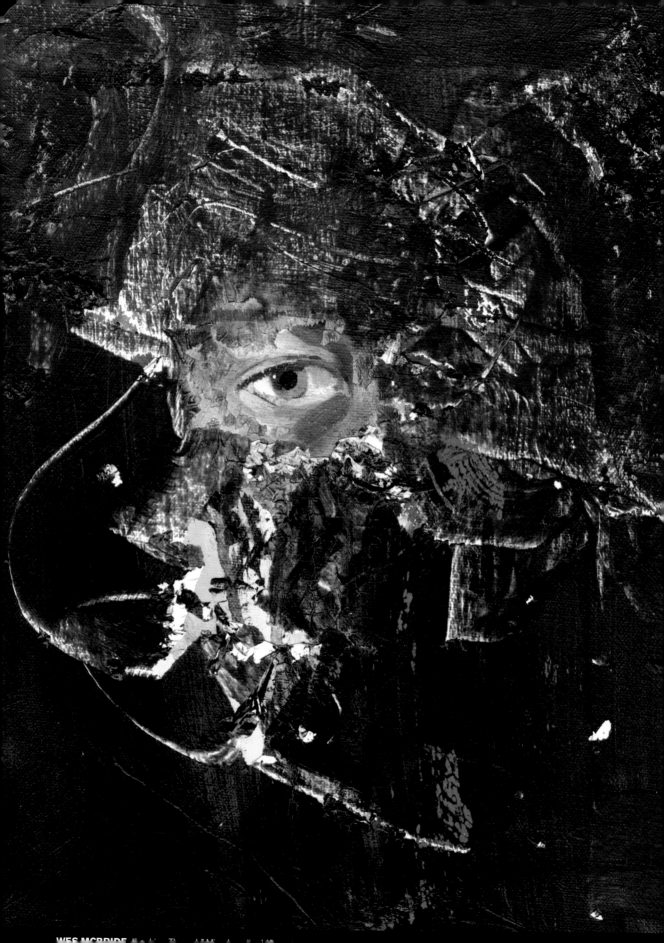

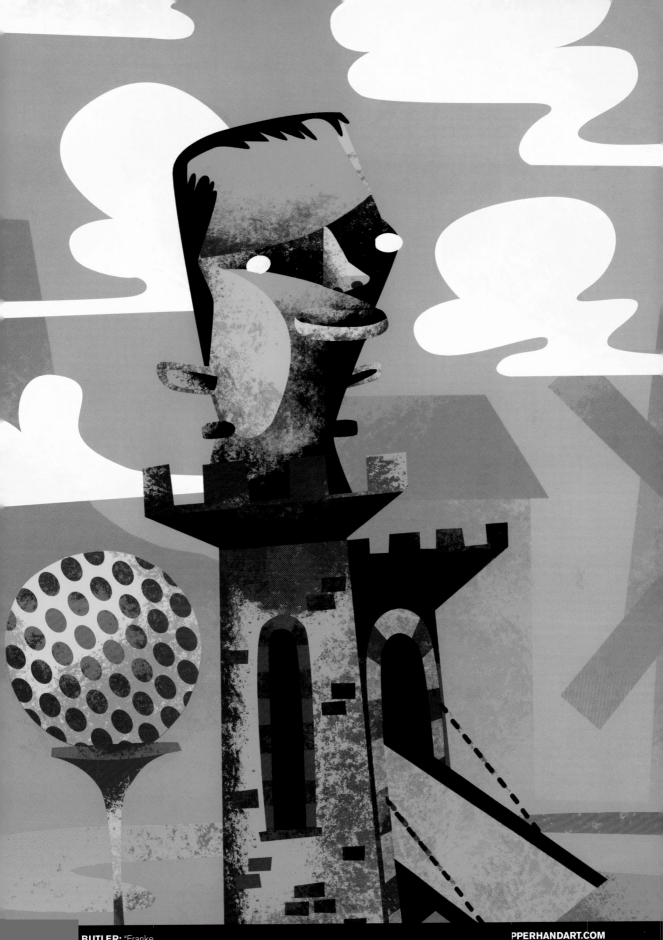

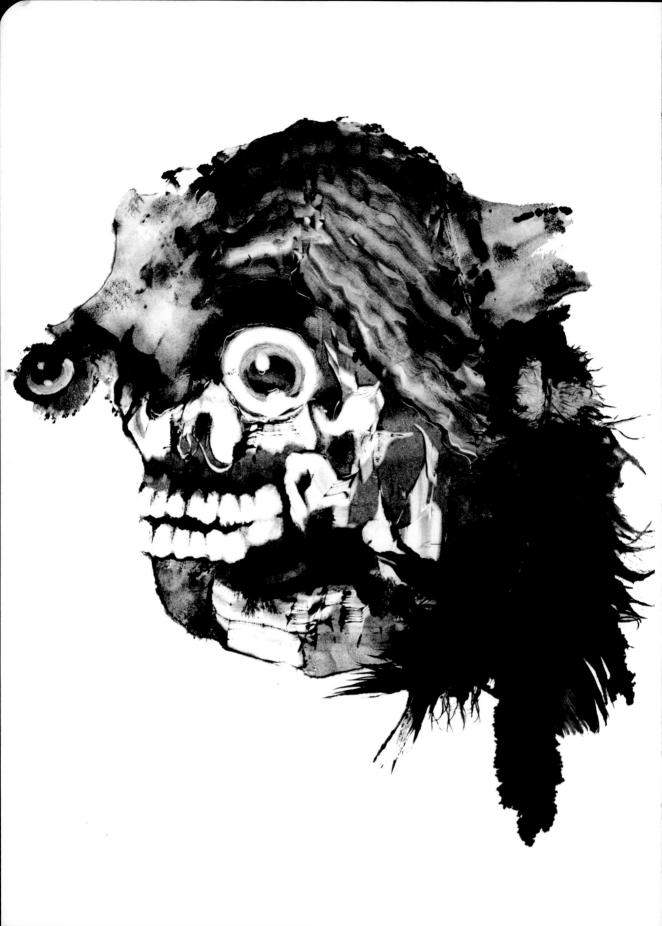

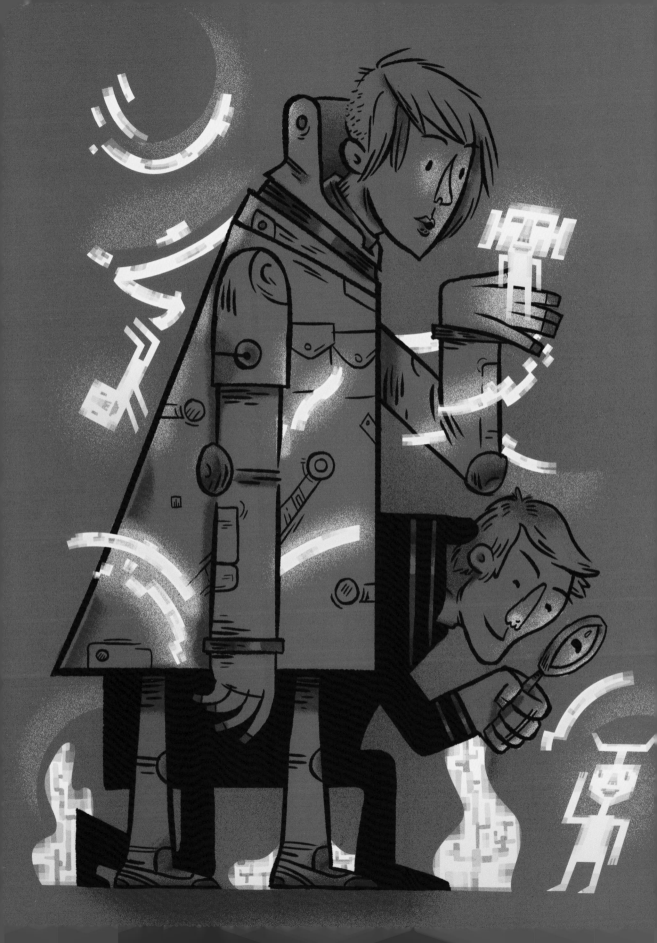

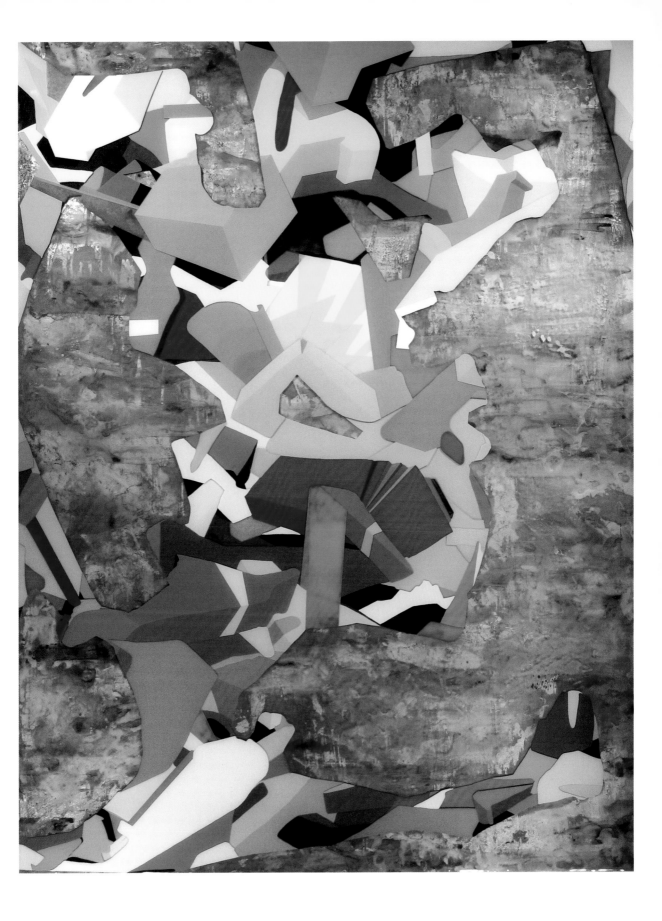

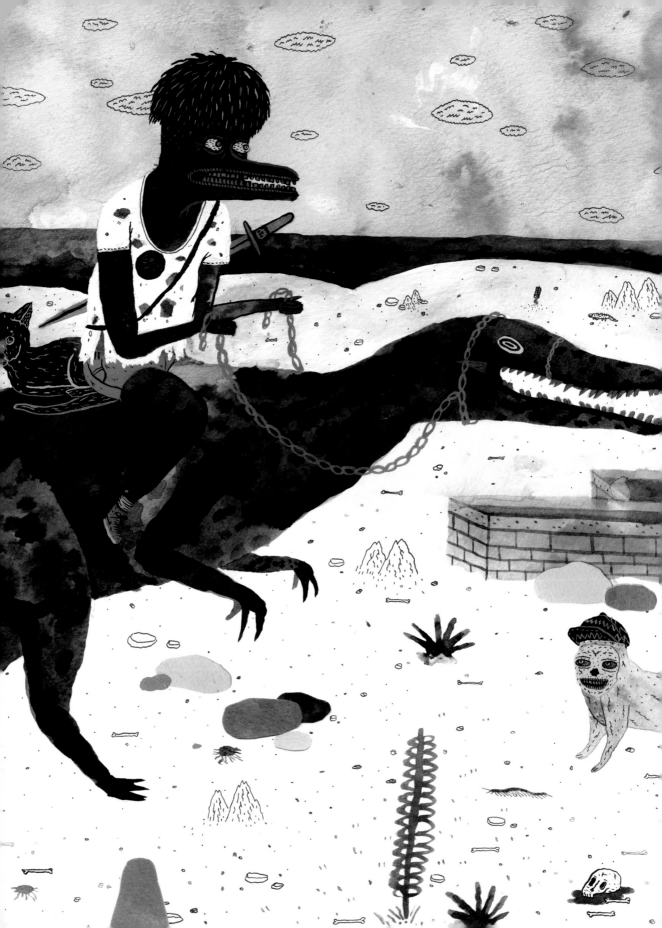

TRAVIS FLACK: "Of Conversations." Destroyed photograph. 11" x 17".

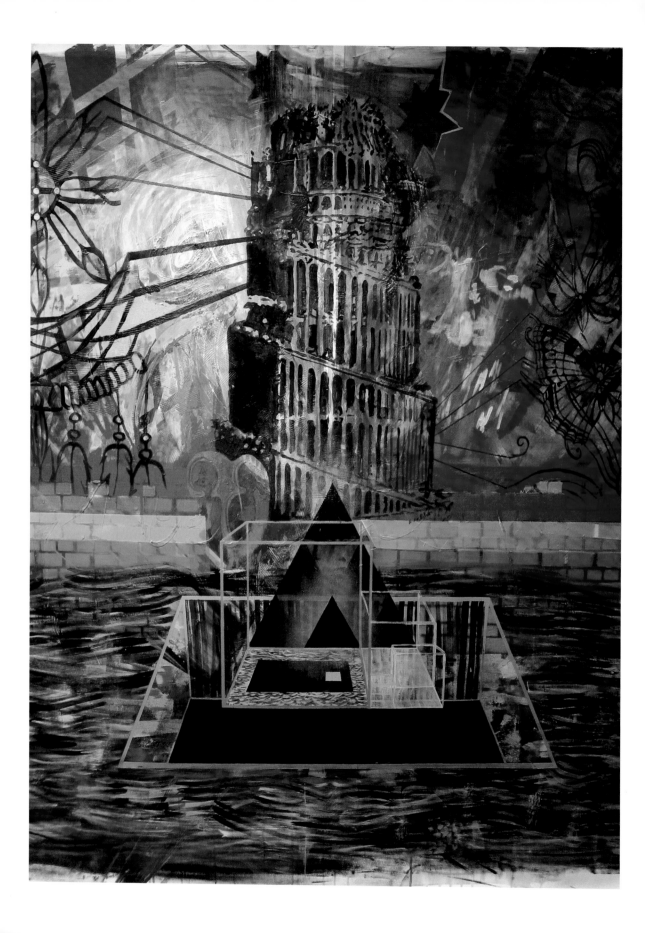

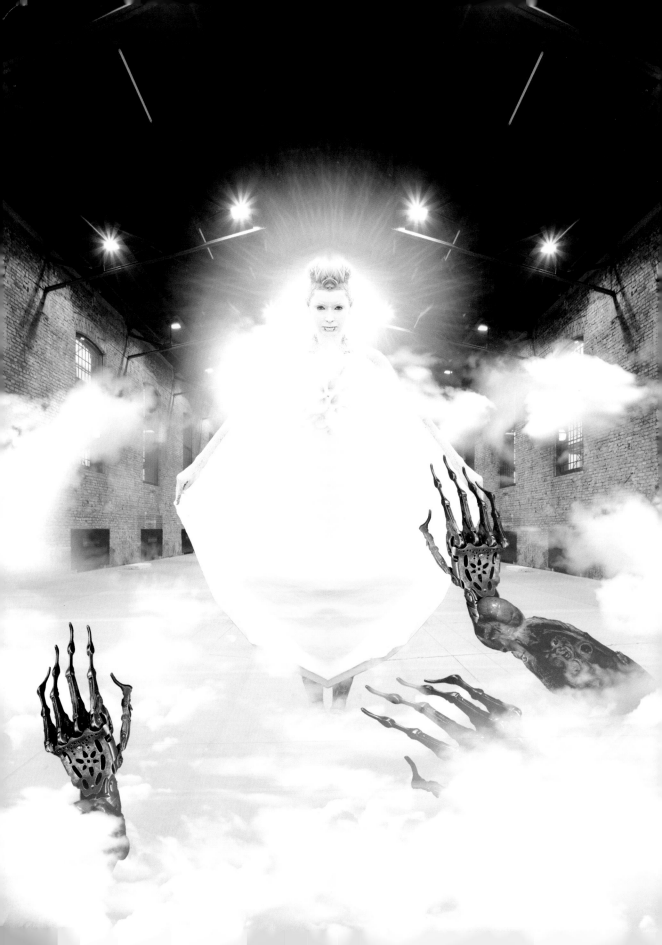

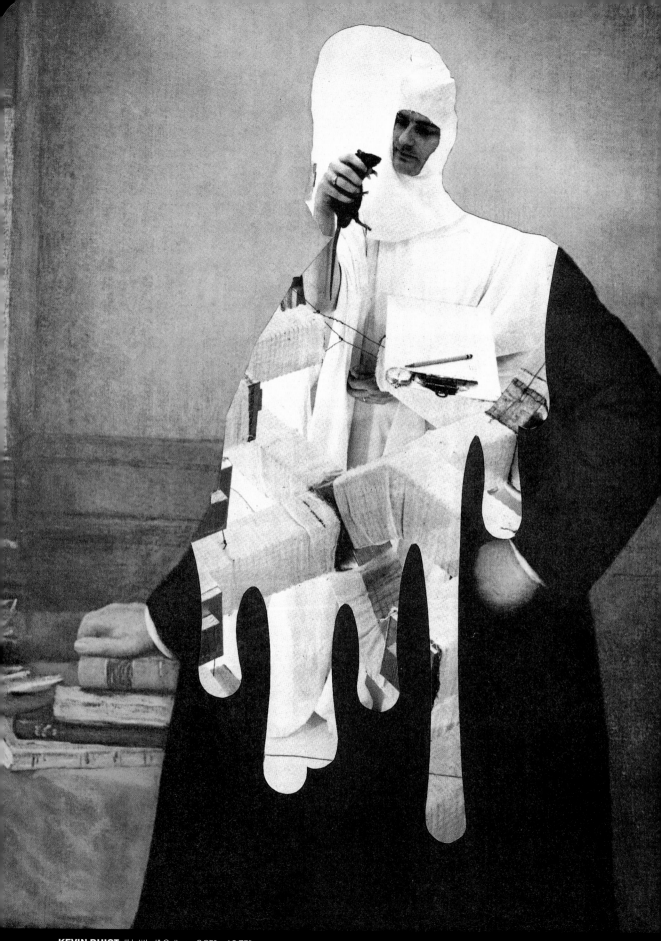

DOUG PEDERSEN: "Piece Untitled #111," Collage. 18" x 24".

DOUG-PEDERSEN.COM

FREEDOM.

ALEX PETROWSKY: "Freedom," Digital print. Dimensions vary. **ALEXPETROWSKY.COM**

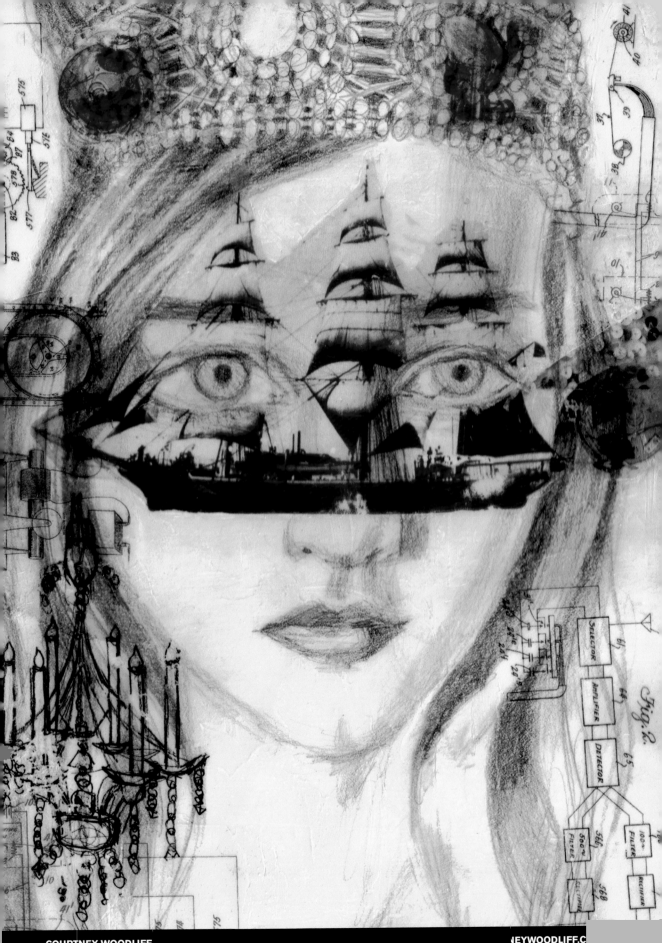

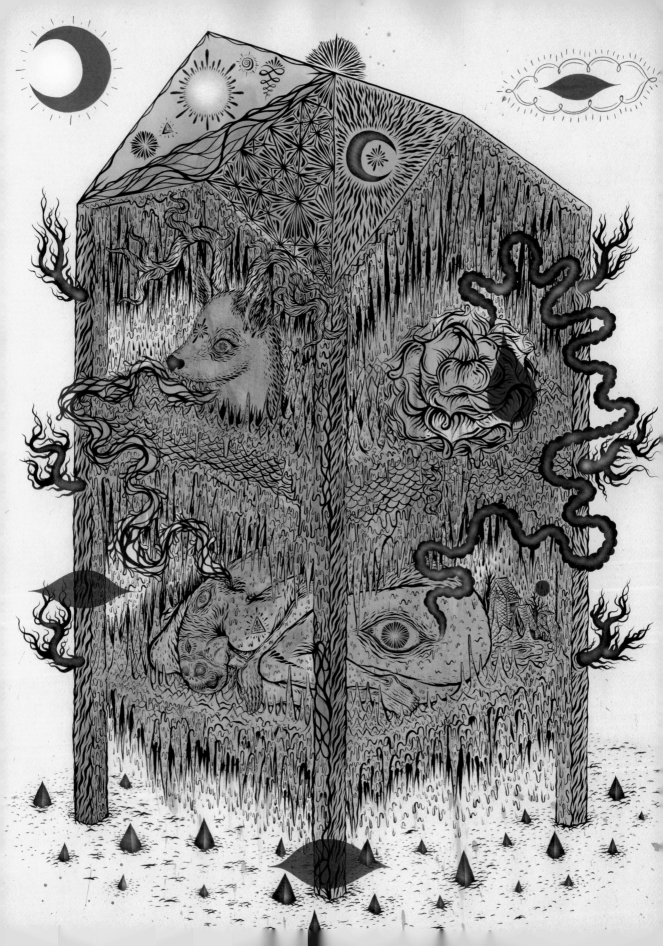

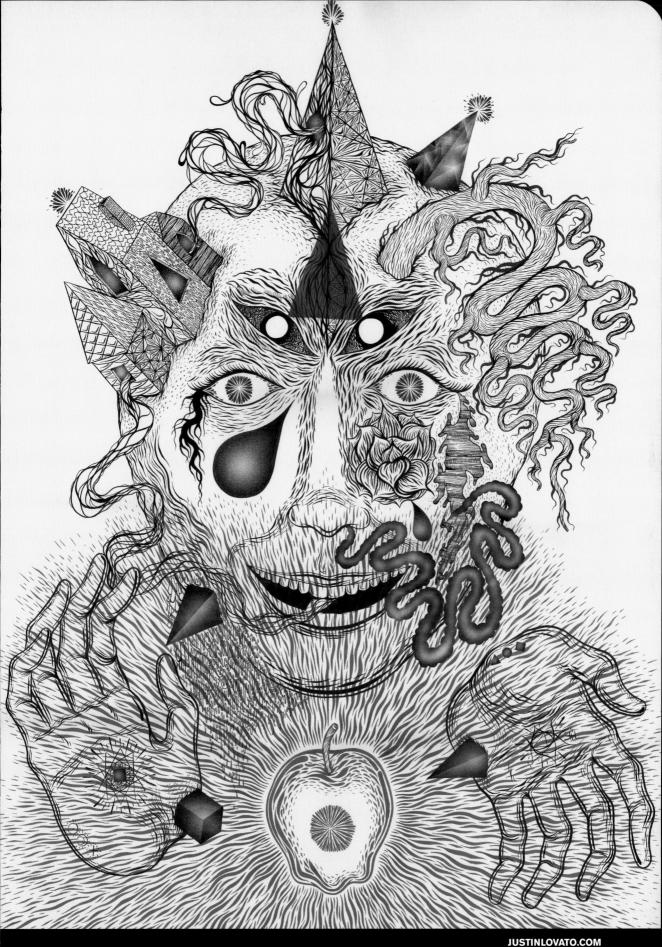

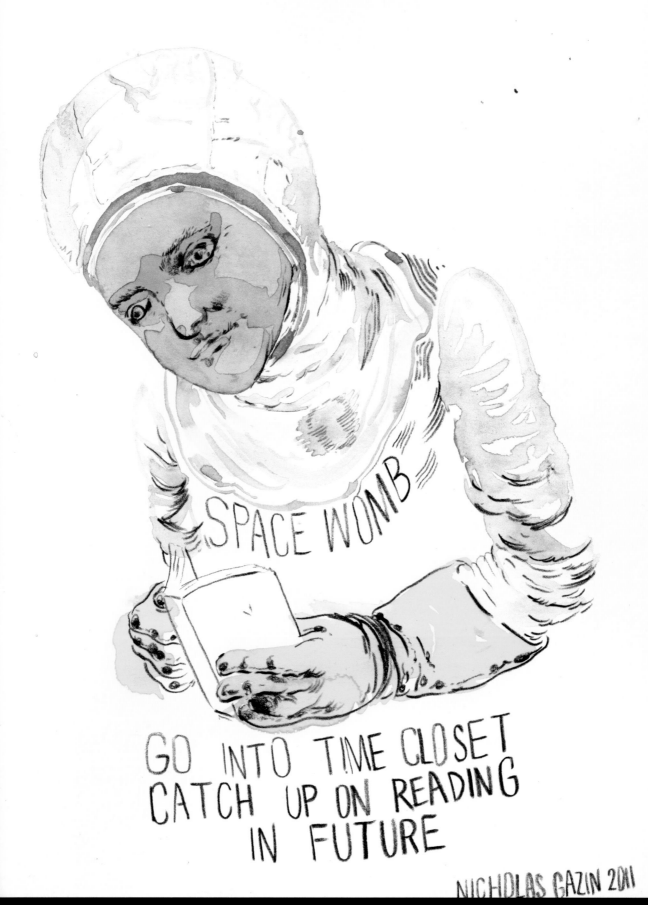

IN FUTURE

RED HEAD WITCHES APPEAR
USE CONFUSION ON YOU
YOU ARE CONFUSED

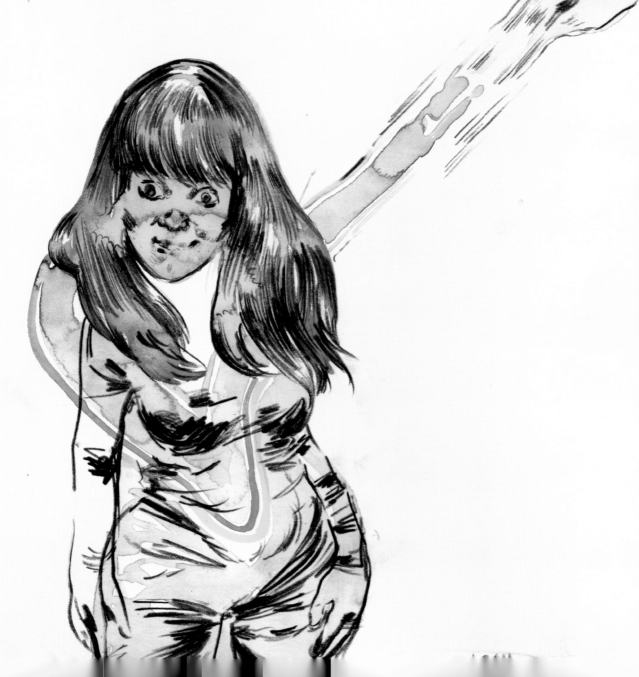

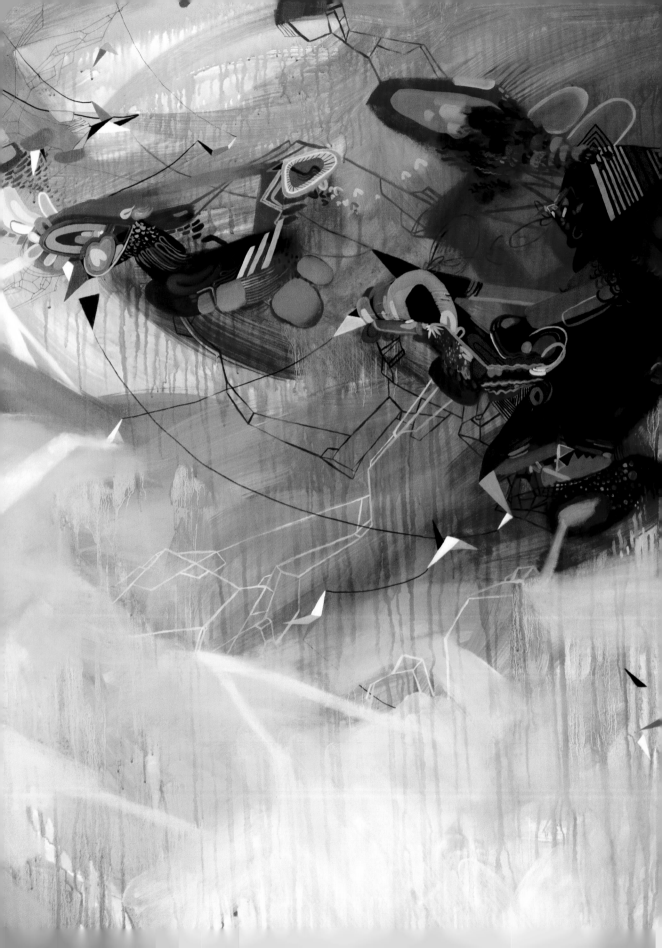

I was born and raised in New Jersey. (A toilet flushes.) That's my story.

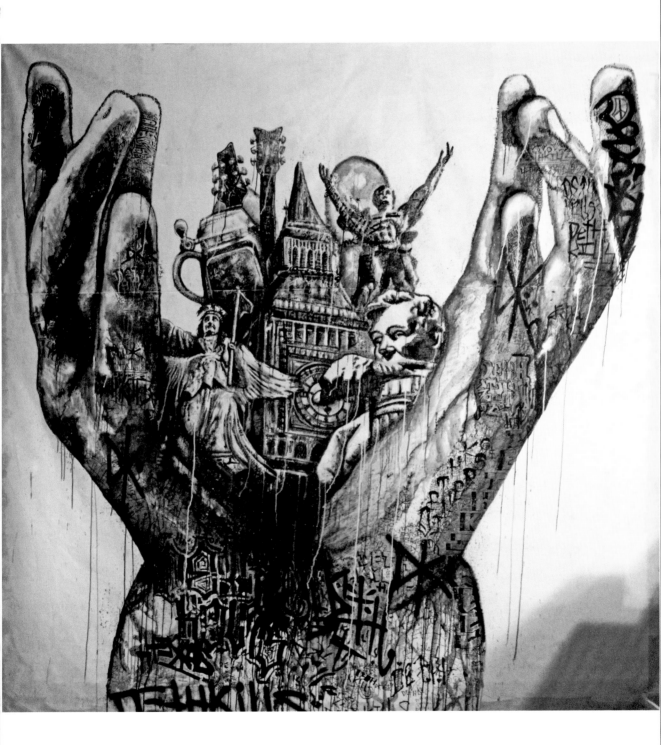

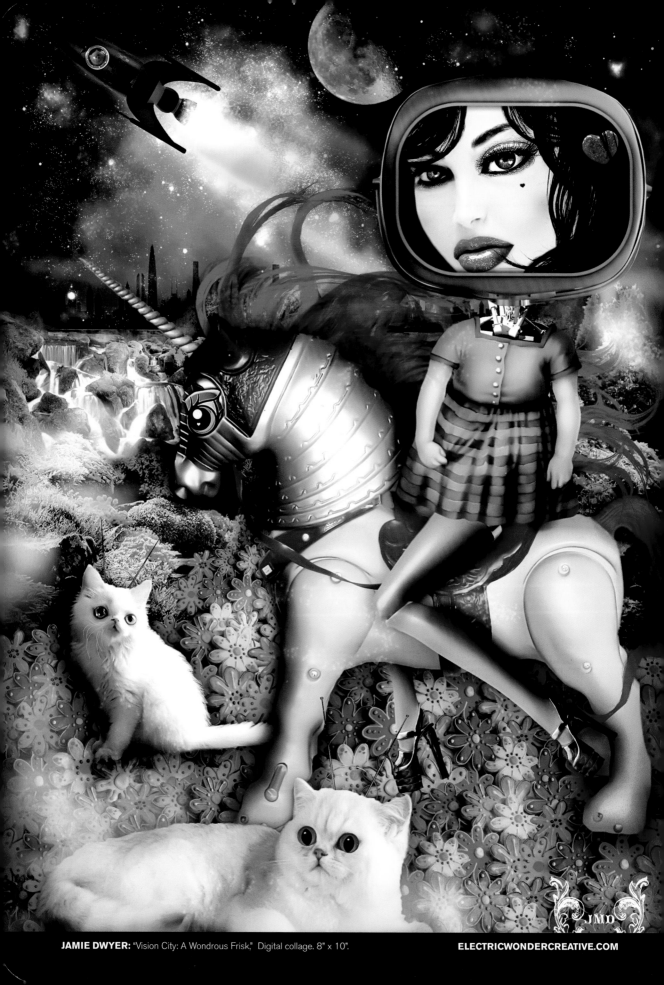

JAMIE DWYER: "Vision City: A Wondrous Frisk," Digital collage. 8" x 10". ELECTRICWONDERCREATIVE.COM

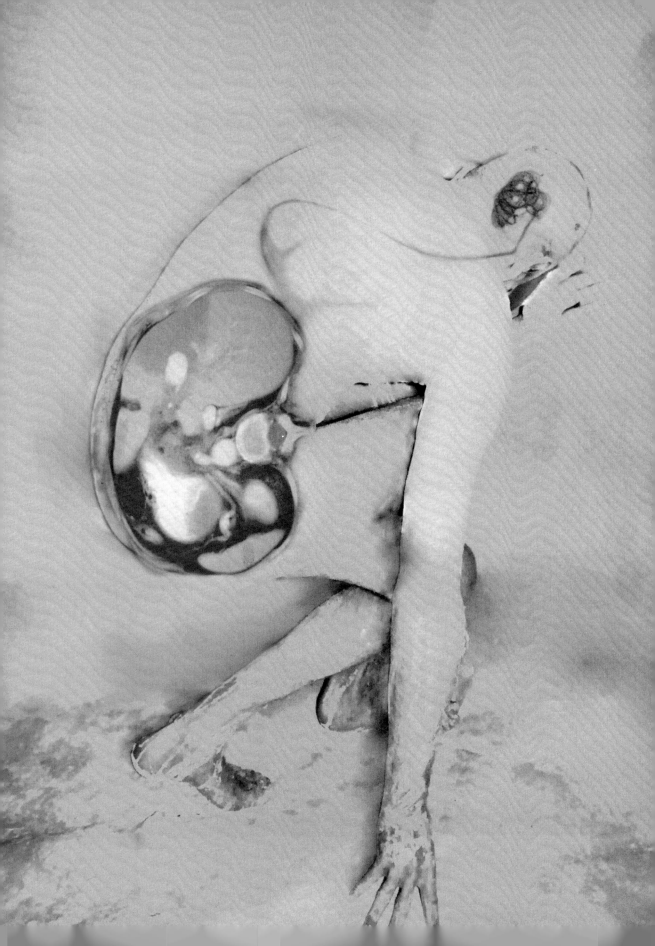

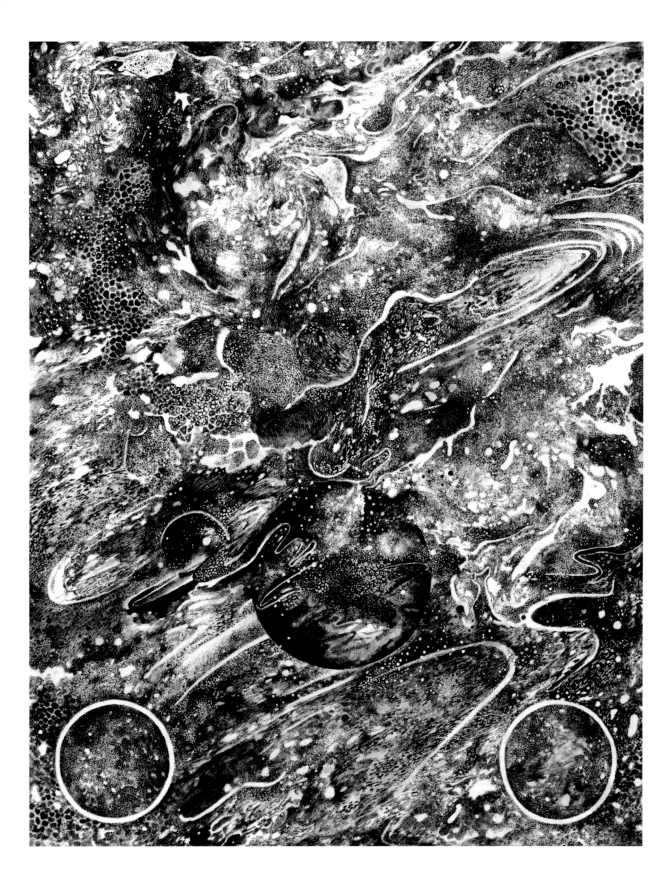

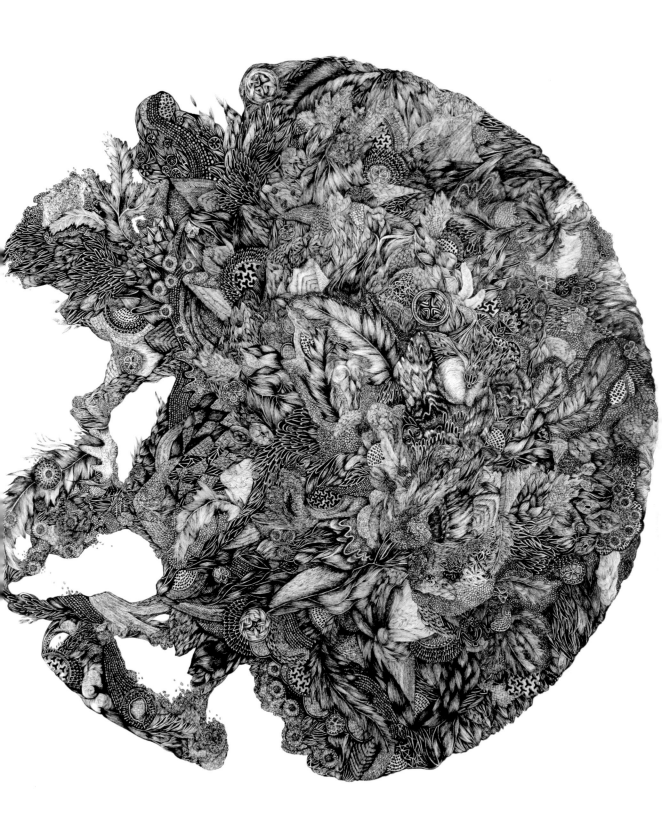

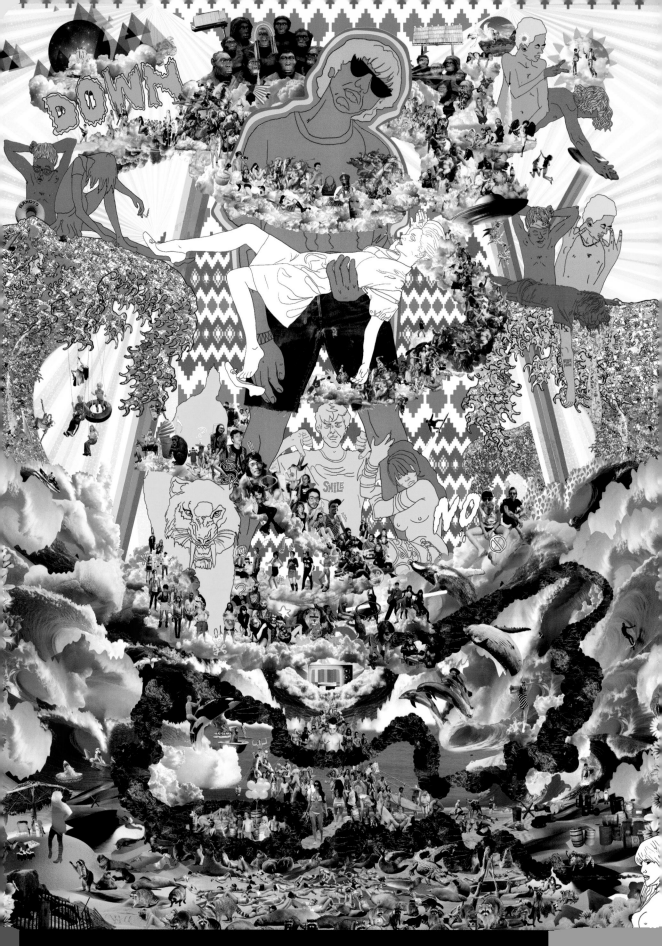

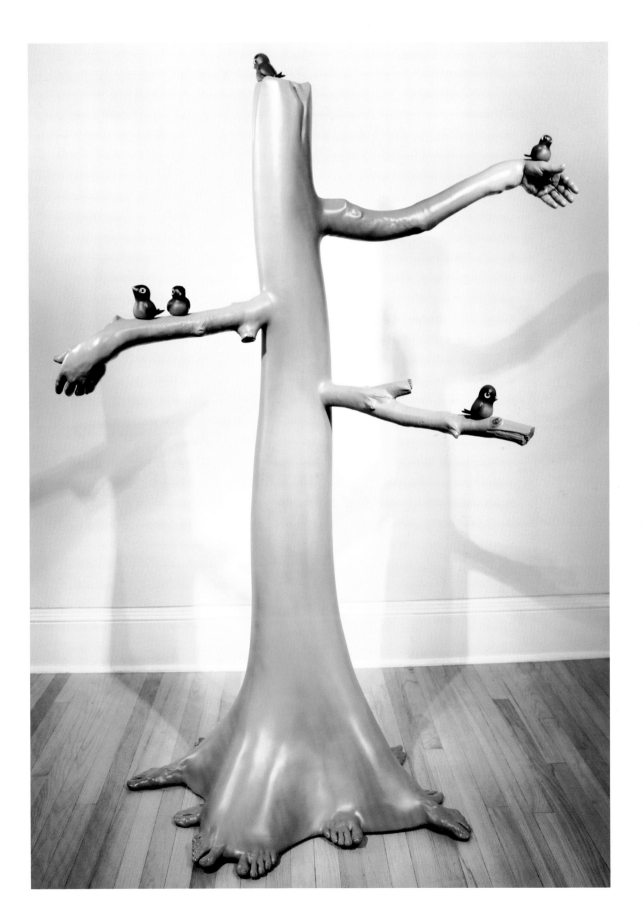

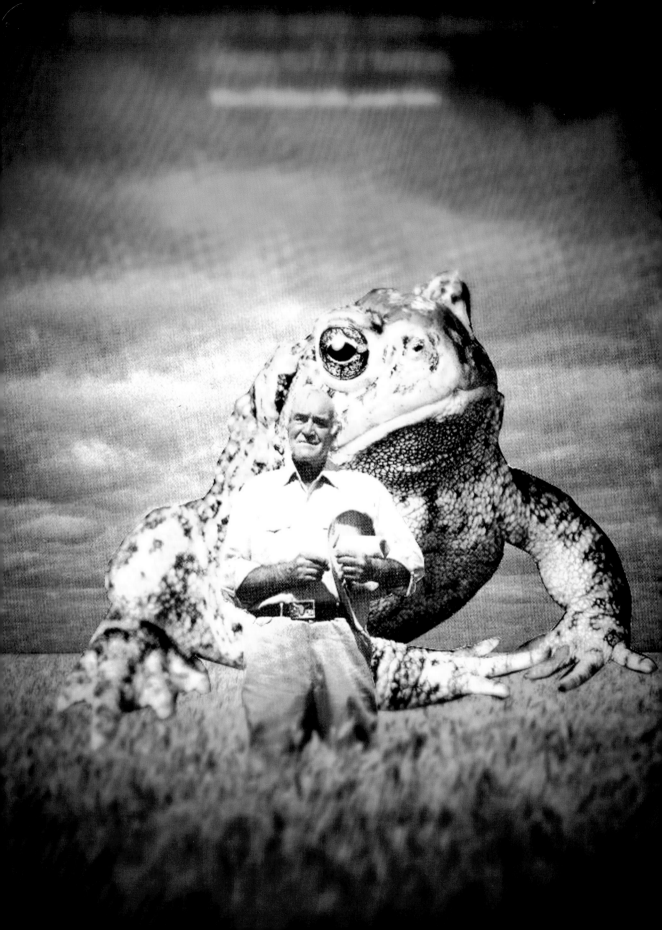

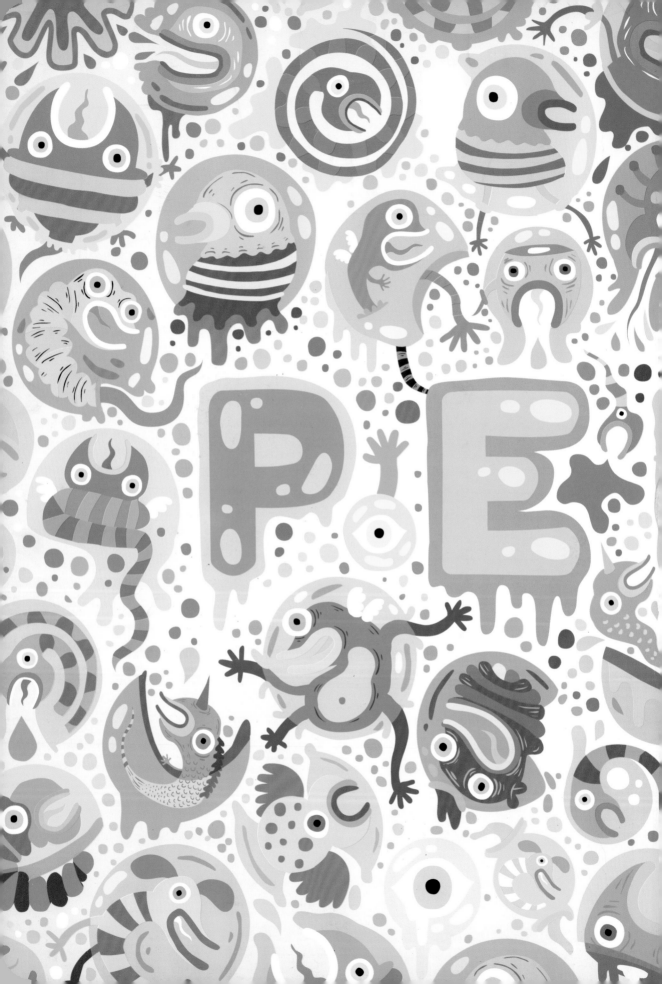